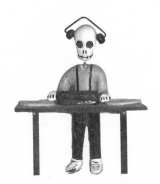

"Our songs are so strong, don't you think?" she said. "I get awfully sick when I hear comparisons to the Roman Empire. They were so much grimmer than we are, the Romans, so lacking in emotions and sentiments. Our songs and cities are the best things about us. Songs and cities are so indispensable. Even if we go into darkness, the time will come when people will want to know how these ruins were made—the essence of the life we made. It sounds very conceited to say it, but I hope that what I wrote will help people start back."

— Jane Jacobs, author of *The Death and Life of Great American Cities,* from an interview with Adam Gopnik, "Talk of the Town," The New Yorker, 2004.

SEMIOTEXT(E) NATIVE AGENTS SERIES

Copyright 2006 © Heather Woodbury

Published by Semiotext(e)
2007 Wilshire Blvd., Suite 427
Los Angeles, CA 90057
www.semiotexte.com

Tale of 2Cities was originally developed with the assistance of the Kennedy Center for the Performing Arts with the support of Countrywide Home Loans, Inc. and the Horace W. Goldsmith Foundation with the President's Committee on Arts and the Humanities. Heather Woodbury and the Public Theater were participants in the Theatre Residency Program for Playwrights, a project of the National Endowment for the Arts and Theatre Communications Group, with additional support from Seagram/Universal. Segments were also developed with the assistance of A.S.K. Theatre Projects and the National Performance Network.

Special thanks to Andrew Berardini and Nicholas Zurko.
Cover Art includes photos by Heather Woodbury, Shannon Durbin and Nick Feller. Chavez Ravine eviction photographs courtesy of the Los Angeles Public Library Photographic Collection.
Back Cover Photography by Nicolas Amato
Design by Hedi El Kholti

ISBN: 1-58435-037-7
Distributed by The MIT Press, Cambridge, Mass. and London, England
Printed in the United States of America

TALE OF 2CITIES

An American Joyride On Multiple Tracks

Heather Woodbury

Contents

ACKNOWLEDGEMENTS

This text is a "living novel" or, a novel-length dramatic work. The ways it works is that I perform newly-written and partly improvised installments in front of a live audience, until a body of material is formed from which is then culled a finished work. First and last, I'd like to thank my director and editor Dudley Saunders, without whose active collaboration this finished work would not have been culled from eleven hours of the initial "live rough draft." Thanks to the audiences who came to these first performances in small spaces in Los Angeles and New York and were midwives to the birth of *Tale*. Great gratitude to the community venues and their guardians who gave me space and encouragement to begin:

The Evidence Room, and Trade City in Los Angeles, Galapagos, El Taller/Latin-American Workshop, NBC @ HERE, The Brooklyn Lyceum in New York City.

To A.S.K. Theatre Projects in LA which provided support and a place in the Common Ground Festival for this initial phase as well. To the Public Theatre, which hosted my seven-month residency in NYC. To all the artists who enriched the work with their contributions and were great company during this generative phase: Actors Reza Safai, José Mercado, Richard Gallegos, Brenda Petrakos, Lauren Campedelli,

Directors Bart De Lorenzo, Patricia Coleman and Dudley Saunders, artist/musician/husband Roberto Palazzo, sound artist Angelo Palazzo, musician Doug Whitney, DJs Reza Safai and Heather Fenby, filmmakers Matt Amato, Lisa Muñoz and Pegi Vail, video documenters Arash and Forrest and performer and oral history-maker Penny Arcade.

Thanks also to those who provided space, funds, help, talent, advice and encouragement to refine this material in subsequent phases: Elizabeth Levy, project manager extraordinaire, John Dias and Bonnie Metzger of the Public Theatre, the Public Theatre workshop ensemble: Bruce MacVittie, Vanessa Aspillaga, Ed Vassallo, Sheila Gordon, Tracey Leigh, Angel Desai and Michael Escamilla. To Heather Fenby for her invaluable advice and editing, Carmen Vega for correcting the Spanish, Emily Cachapero and Sheela Kangal of TCG, Rose Parkinson and the Galway Arts Festival, Erin Boberg, Kristy Edmunds and the Portland Institute for Contemporary Art's TBA Festival, Terry Cannon and the Baseball Reliquary, Michael Gennaro, Martha Lavey, Tim Evans and the Steppenwolf Traffic series, David Robkin, Amit Intelman and the Steve Allen Theatre.

Heartfelt thanks to David and Helen Weinberg who shared their apartment for seven months and explained baseball to me, and to my husband Roberto and my dad Mark for coming to visit me in NY after 9/11. And to Larry and Beck and Jack Fessenden who also shared their home with me. I'm also indebted to photographer Don Normark for his inspiring testament: *Chavez Ravine 1949: A Los Angeles Story*, to Suzy Williams for giving me his book, to Stephanie Meckler for being the first to inform me of Chavez Ravine's history, to my mom Marda for her memories and research clippings, and to Phil Norwich for taking me to a Brooklyn Cyclones game. Finally, to Hedi El Kholti and Chris Kraus of Semiotext(e) for their razor sharp intelligence and awesome aesthetic insight.

Heather Woodbury in *Conversation*

with Ira Glass

Heather Woodbury is a performer, novelist, playwright, and/or a unique melange of all the above in various combinations and often all at once. She was interviewed by Ira Glass as a part of a performance of *Tale of 2 Cities: An American Joyride on Multiple Tracks* for the Traffic Series at the Steppenwolf Theatre on June 3, 2002.

In his introduction to the performance, Ira remarked that he'd first encountered Woodbury years ago when he received tapes of all 10 hours of her first performance-novel *What Ever* and "was stunned by its sheer ambition."

Ira Glass: *Heather, what was the genesis of this work? Were there particular characters you knew you wanted to do, or was it the history that was drawing you?*

Heather Woodbury: First, it was the history, the feeling of displacement, the eradication of a life that you knew. After leaving New York City, I went back to visit only to see my favorite neighborhood utterly transformed from what it had been in the past. When I first moved to Southern California, I had this yearning for New York. And the neighborhood that I'd moved to in Los Angeles, Echo Park, just evoked this sense of loss.

Is Echo Park where your story takes place?

It's right over the hill from the three barrios that were destroyed when they built Dodger Stadium. A whole neighborhood was simply wiped out. My mother grew up partly in the Flatbush section of Brooklyn with her Jewish relatives, near Ebbets Field, where the Brooklyn Dodgers stadium was replaced by the Ebbets Housing Projects. So, the character Miriam harkens to this Jewish, leftist part of my heritage.

And in the New York story, (when Miriam's attacked by a gang of 13 year old girls) the Ebbets Field Case, is that a real case? Or is that completely fictional?

I made that up. And then, you know, strangely, I was planning in the plot for it to be this huge brouhaha that would just turn into a sensational, controversial case like the Central Park Jogger case, where the victim lost her memory or the Tawana Brawley case where a young woman said she was assaulted but it was ambiguous. But as I was creating the piece, September 11th happened, and that wiped out everything. I had to let my characters acknowledge that. The piece took this turn, after 9/11, where people stopped giving a damn about whether Angela did the crime or not.

Is that what happens in the third part?

Yeah, and the fourth, and the fifth, and the sixth. *(Laughs)* Brevity is not my strong suit, as we all know.

How many parts are there to the show?

Originally I created eleven one-time-only, get up and do it in front of an audience, fifty-minute segments. And then my collaborator,

dramaturg Dudley Saunders and I sat down with this eleven-hour thing and turned it into a five-and-a-half hour thing.

At what point does September 11th happen in the five-and-a-half hours?

In the third act. Which is interesting because the whole play is really about monumental loss to begin with.

One of the things that happens in your earlier piece, What Ever *is that the ghost of Kurt Cobain keeps showing up for people. And I wonder now, does it feel a little odd even to be talking about it?*

I worried about that before, but then it just really didn't matter. *What Ever* is like a novel, in the sense that it took place in 1985, so it has those signifiers. And then, amazingly, Kurt Cobain just continues on; I keep hearing Nirvana on the radio, so he is haunting us.

When I watch you perform, I react to some characters with more fondness than others. I always wonder if you love them all equally, or if there are some that you are less fond of, or have negative feelings about?

In this piece, in *Tale of 2 Cities*, I really did try to go further into the heart of darkness. People do bad, terrible, unkind things. But I don't know, I still really feel for them. Like Richard the cop—he just kept coming back, talking about going to Dodgers' games, and you started to really get fond of him, even though he's a racist, horrible cop in lots of ways. Angela's also an ambiguous character: you don't know whether she did this horrible crime or not.

Are the characters based on actual people?

Not really. They tend to be amalgamations of people I overhear, or sometimes, literary people. The hobo scenes are based on this real Hobo Ridge, but they're also inspired by Steinbeck and Twain.

Portnoy?

Portnoy? *[both laugh]*

Is that a hobo name?

Well, sure. Ed Portnoy. Why not? I don't know. He's from Texas.

Do you ever choose to study the way somebody talks and acts, or is everything more unconscious? Like, 'I'm going to do a certain character, I'm going to listen to this kind of person, and hang out with this kind of person to get that sound in my head.'

It's almost the other way around. It's like the accents lead to the story. I walk around a lot and I just hear my new neighborhood. I heard this very particular Mexican-American accent in Echo Park, and it turns out a lot of people are actually from El Paso, Texas. It's very distinct, a slightly Native American flavored accent, with its own cadence and rhythm. I would walk down the street and just imitate bits of conversation I overheard. Repeating it just as I heard it. But then I want to find out more. I start off in the voice, and just ask the person to keep talking. The whole piece began with Manny the Deejay lying in bed, trying to decide what to do about his dead grandmother on the kitchen floor. His voice just came right out of me, a very angry, artistic young male voice and I said, 'OK, I'll follow this story.'

Was that before you had Ebbets Field?

No. I had the idea and the theme. I guess I start with a feeling, and then I figure out what it means on an intellectual, thematic level. From there I just start absorbing people and voices and images, and weaving those fragments into a story.

It's interesting that in this play, the character Miriam actually goes around collecting people's stories and their voices. But I get the feeling when you see Miriam writing down Gabriela's stories, you are not exactly trusting her motives. It's like, what's in it for her?

Yeah, and then that's me too! What does it mean to kind of be an anthropological appropriator of other peoples' lives and stories? I had mixed feelings from the outset about not being Mexican, or a baseball fan either. Why was I saying I could tell their stories? A lot of my characters are ambiguous in that way, too.

I would expect that when you perform the show, certain scenes are completely fun to play, and others are like, 'OK.' Like tonight, what were the scenes you found yourself looking forward to, where as soon as the scene started, you'd think 'Yes, yes, let's go!'

Well, the hobo guys. I really enjoy them.

Is it just because they're so, like, out there?

I like their language. I just relate to them. It's like Violet in *What Ever.* I like these older people who are replete with histories within histories within histories. I feel like I can just luxuriate when I'm doing those.

Wentworth has that too. Like his beautiful, formal way of talking. How thoroughly do you imagine each of the characters in the hobo scene? Do you know what they're wearing? How deep are you into them?

I do kind of know what Wentworth and Portnoy are wearing.

What's Wentworth wearing?

An old suit with a vest.

And the other guy, Portnoy?

Well, Portnoy's wearing a cowboy outfit from his movie. I see Wentworth wearing an old, little crusted, stained suit. I was very inspired by some photographs taken by this photographer, Don Normark, of Chavez Ravine in the forties. Really remarkable photographs. But then Normark left, and he never knew what had happened until he came back fifty years later, and found all these people who called themselves 'Los Desterrados,' the uprooted ones, who still meet and talk at a church in Solano Canyon. He got them to go through the photographs and write down their memories. I didn't take anybody's direct stories, but I was very inspired by them and the tone, and this strange sense of a village right next to downtown LA.

Let's open this up to people in the audience and if you have a question, just raise your hand. [audience members ask questions] *I'll just repeat for the people upstairs, there was one polite question and one rude one.* [audience and Heather laugh] *The polite one was 'Talk about Pacifica Radio's influence on you,' and the rude one was 'So how does this work out for you economically?'*

I guess you're referring to my New York lefty radio host Jan, of "Tawk Yur Head Off"? Yes, well I grew up in Berkeley, which has the infamous KPFA and then New York has WBAI and this is just my fond homage to rambling leftist radio, which is the last

redoubt of unfettered mass media. And in response to the rude question, I am making a living now, but I haven't always and yeah, it's a bitch, basically.

[audience question] *The question was 'Why not use a headphone-microphone as part of your act?'*

Because I don't really want to have something on my head. I like having my head and my face to use. But I do use a microphone because I can't do all these different voices and keep my voice, performing week after week. The male voices sound better on the mic. And also, I come from more of a punk-rock generation and I just like to run around with a microphone in my hand on stage. *[laughs]*

[audience question] *The question is about structure, how you structure, and if we were to see it the show a week from now, would everything be structured the same way?*

If you were to see this particular track? Yeah, it would be exactly the same. Unless I rewrote it ...

Exactly the same, with all the dialogue and everything?

Yeah.

It's completely set?

Yeah, I mean, when I create it, it isn't. Basically what I do is I write it at the very, very last minute and without enough time to memorize it and when I get up on stage it's almost like this second draft comes out on the tongue.

And do you record?

Yeah. And then when I rewrite it, I try to calibrate. 'Oh, was it better when I kind of got off the subject and rambled around and improvised?' It's a long process, and I'm still basically in that process. So the play that I've written could change quite a bit, but it would probably change on the page, it wouldn't change on the stage, if you understand the distinction. I would be sitting there, going 'Oh, oh why don't I rewrite it this way?' I wouldn't be getting up in front of an audience and changing it.

One of the things I was wondering about watching you is it seems like there are two, three different ways you could be staging this story. One is when a character just tells somebody's story: like while the two women are doing the hair, one of them tells the story about being up on the hill. You set up a context where one person tells, and the other reacts. But at other times, the story actually unfolds in front of us, like the interrogation scene at the beginning. One seems inherently more active, but harder to pull off because you have to get all the characters in motion. Do you think, sometimes, 'OK, this shouldn't be a story that people tell each other, it should be a story I'm just going to act out for people?'

Yeah, I play with that a lot. I guess usually when I'm writing something, I start with images. For instance, I went to Coney Island on Easter and I saw all these things and I took notes. I had a feeling about the place, on Coney Island, Easter. I kept trying to write it and then as my story came to me, I thought 'Ah! I know! She'll tell this whole story during an interrogation. I'll have Angela tell this whole story.'

What about something like Miriam's niece Hannah, who's typing on the computer? And why does it seem more natural to type up here than down here?

Well, it's not more natural. It's less natural and more expressionistic and weird and funny.

The story she tells to Josh over the computer is a story you could just stage. She could be at Starbucks and Rabbi Dave could walk over.

Yeah, that's why I call it a performance *novel*. Hannah's scene is more novelistic. I do have a lot of stuff that's playing with different written forms. But things tend to get more propulsive as the story continues. Later on, you actually do meet the Rabbi. It's kind of like Violet in *What Ever*: she sits around for the first half just telling stories and then she kind of gets into the mix.

And moves across country.

Right.

If Hannah's typing, she can also comment on the action.

Right, but some of her e-mails are more active than others. In the first act, she's emailing, crying and saying, 'Josh, our aunt has been attacked and she's in a coma.' There's the absurdity of having to say that in an e-mail, just hating the computer and then it disconnects her in the middle. I'm interested in all the different ways that we communicate and how those ways have changed. We live oftentimes in isolated, little bubbles. So Ira, do we?

I do, God knows...yes? [**audience question**] *The question is do you discover where you're going while you're writing?*

I start with sort of an itch and an ache. And I keep scratching and trying to find what is that feeling. And I do a lot of boring diary entries about 'The theme is...' [laughs] So yeah, I do come up with a kind of intellectual construct, but I'm always happy if the piece disproves my intellectual construct, or questions it, or expands it.

[**audience question**] *Could you see somebody else performing it?*

Somebody *elses* have already performed it. I did it at the Public Theater. I got a Kennedy Center grant and a NEA fellowship, which enabled me to earn a living this year. And I chose not to act in it at all. It was done with an ensemble of seven actors and I was very pleased with it. It was wonderful to see my own work without putting it across myself. I think every artist wants to be disseminated, they don't want to have to be there and do it all just to be heard, so that was very satisfying to me. And the people embodying the parts - it was so good to see the guys played by guys. [laughs]

They can make their voices just so deep sometimes.

I can see that.

[**audience question**] *Do you forget or get lost up there?*

Yeah, I do, and I just try to stay in the place that the people are in. I get lost when I start thinking 'Oh, I'm in the theater and people are watching me and I'm going to forget my next line,' instead of thinking 'Oh, I'm doing hair and I'm thinking about....' If I just get

back into to the place that I'm in, then I'll say what comes naturally. A lot of the lines that I originally performed got totally lost, and good things happened. More interesting, natural speech happened, little additions cropped up, so those are now incorporated into the script.

Did you lose your place at all out here tonight?

Yes.

You did? Where?

I'm not going to tell, that's bad luck. Because then it'll screw me up the next time I perform: 'This is the place where I told everybody in Chicago that I lost my place.'

[**audience question**] *That was a really eloquently stated question that I won't be able to repeat. What she said is that some of the characters, if I have this right, they express many different world views, some of them more about the physical world, some about cultures, some about religious things. So, do you have one that you're trying to express? I feel like I'm translating from English to English and so badly.*

I never want to just specifically say one thing. I always say that if I could say it, then I would write an essay rather than a performance. I have a specific feeling and specific ideas that I'm trying to illustrate. The piece should move or provoke people on their own terms.

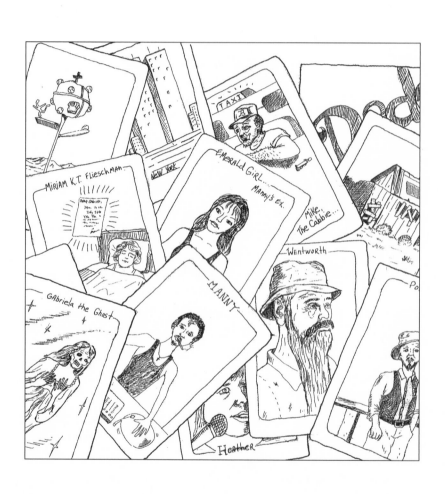

Characters

TIME: 1941-2001
SETTING: New York City and Los Angeles
NOTE: In this piece, all temporalities, all histories and places are simultaneously present—and equally isolated and ghostly.

CORE CHARACTERS:

Gabriela née Zorrita Hauptman: Manny's dead 61-year-old grandmother grew up in La Loma, one of the three Chavez Ravine barrios. Now a "hungry ghost," she traverses past and present via boulevards, paths and freeways in LA, passing through people and places and times.

Manuel "Manny" Vasquez: a 19-year-old talented but troubled mix artist (Deejay). He is spinning a lonely mix over his *grand-mami's* dead body, blending his "disappeared" familia's abandoned record collections, recalling his past, haunted by his present.

Miriam née Klinger Tromble Flieschman: a leftist Jewish activist from Brooklyn in a coma after a mysterious attack at Ebbets Field Housing Projects. She lived in Los Angeles in the 40s and 50s with her first husband Lonnie Tromble, befriended Gabriela as a child, and got involved in local politics.

Angela De Mayo: A 13-year-old girl living in Ebbets Housing. She is suspected of being the ringleader in the attack on Miriam.

Hannah Klug: Miriam's angry niece stands vigil over Miriam in the hospital, e-mailing her brother Josh and reading her aunt's old letters and diaries.

Lavinia Esmeralda Octavia, "Emerald-Girl," "Esmé": Manny's ex-girlfriend.

Mike Rafferty: A diehard Brooklyn Dodgers fan. Cab driver.

KEY CHARACTERS

Samuel Wentworth: The proprietor of Hobo Ridge in 1940s–50s. He's extremely old—over ninety.

Ed Portnoy: Wentworth's ornery Texan drifter tenant.

Mr. Dreyfus: A mad old man building a religiously obsessive junk sculpture on Hobo Ridge.

Carolinda the Hairdresser: Gabriela's childhood friend, a former Chicana activist.

Viviana the Hairdresser: Gabriela's childhood friend, the owner of the Beauty Salon.

Richard the Cop: An older detective on the Ebbets Beating Case, a former Brooklyn Dodgers fan who grew up in Flatbush.

Rabbi Dave Dovkind: A pot-smoking Hassidic Rabbi who's big on the Kabbala and the Yankees.

Josh Klug: Miriam's nephew, Hannah's brother. He has a hi-tech company in Korea and is also a Yankees fan.

Chuck the Cop: Richard's younger partner from Long Island. He doesn't follow baseball.

Skullvato: Death as low-rider.

Core-US: Multitudes of voices, characters from Los Angeles' and New York City's past and present; all sounds and signs which comprise the texture and grid of these two cities.

PART ONE

GRIFTERS, DRIFTERS AND DODGERS

Prayerscape in

Diamond Shape

LA Core-US

Los Angeles, 2001

Miracle Mile. A Filipina hospital worker waits at a bus stop.

BUS LADY: Where is the bus? Where is the bus? Where is the bus? Where is the bus? Where is the bus? Where is the bus? Where is the bus? Where is the bus? When will it ever come. Where is it? I am hot, I am hot, I am hot. I wish I had taken off my orderly shoes and put on my sandals. God, please bring the bus.

Gabri in the Gatocombs

Los Angeles, 2001

In Echo Park, a Chicana grandmother lies dead on her kitchen floor, her hair spread around her head. Two little kittens pull at strands of her hair, mewing curiously.

GHOST GABRI: I am in the cool. The *gatos* comb my hair with their claws—the little cats, *gatitos*, born only three days ago to

Blinky, the one-eyed *puta* girl *gata*? They mew from their hiding place under the stove and comb their tender baby claws in my silver hairs. (Her voice starts spooky and whispery and becomes increasingly casual. She has a Los Angeles Mexican accent, also like an El Paso Mexican accent, since many in this area migrated from El Paso. Her manner is sorrowful, but with a certain matter-of-fact humor.)

I feel a cool, *como* cement, like my long gone *barrio*, that hill the tractors clawed into a ballpark. Am I wiped away? Claimed by tractor claws? The *gatitos* comb my hair in this still. *Me molesta*! It annoys me, as if I were a little girl sleeping and not a dead grandma lying on her kitchen floor and waiting for that dang grandson—the only one left around—that dang grandson to GET OUT OF HIS BED, come out of that goddamn (forgive me Virgin and Son) come out of that gosh*dang* room—and do something with my dead body.

He came waltzeen in after partying all night three nights back. He came hip-hoppin' in at four o' clock in the morning and found me lyin' there dead. Hunh! Boy was *he* surprised! He couldn't handle it. Manny, *Manolito*, Manuel. Leave him to stay there in that room he painted the color of blue Kleenexes! He never heard me when I was alive, why would he hear me now I'm dead? All he hears is that crazy mixed up music he plays *todo el tiempo*.

Was it a stroke or a heart attack? Heart attack maybe I think. I felt it bad in this one arm.

LA Core-US

Los Angeles, 2001
Loyola Marymount University. Two KXLU disc jockeys rush up to change records, having just had a pot break.

RANDY: Uh, that wis, that wis, that wis—whue wis that, Damon?

DAMON: Uhhhh, yeur listening teu KXLU? It's gettin' onnn five o'clock? and em, that wis Echoandthebunnymin? and befeur that Door Thistle? and befeur that Tucky Bird...Tucky Bird. Randy brought Tucky Bird, I don't know whue they are, whue's Tucky Bird, Randy?

RANDY: Hum? Oh, I don't know man, I fergot. Wer sooo hungry

DAMON: I know. We are? Wer like on a desert island heur?

RANDY: Yeah, we need some sweet lady whuese listening out thur to bring us sum feeeuuud?

DAMON: Shut yer mouth, dude.

RANDY: Listen to this and somebody come feed us...

Miriam Goes to La Loma

Los Angeles, 1947

Miriam writes a letter.

(Her accent is that of the Brooklyn Jewish intelligentsia, circa 1940s. She has a light-voiced, slightly musical, cadence.)

May 6th, 1947

Dear Ester,

The heat of Southern Californyer is not like our Back East heat. It's not hot, like Brooklyn, that steaming sooty hot I almost miss, as if the city were sweating out all of its devils. No, this is a flattening heat, a burning, not a stewing. No melting pot this, but a fry pan.

Ruth Davies, (the woman Lonnie refers to as a 'dangerous do-gooder'—he can be so doctrinaire with his party politics at times, Lon, meanwhile he's going nuts trying to write for that studio!—

anyway—) Ruth Davies came by the other day in her aging Ford and motored me over to the base of one of the Spanish ghettos. They call it La Lomer, which means the hill. From there, I walked up into the center of what I would almost call a village. (But I don't mean that it was like Greenwich Village!)

Lonnie says the Mexicans call them barrios and somehow that does sound appropriate. Sounds the way it looks if you know what I mean. Perhaps because the valley itself is curved like a wheelbarrow and my mind associates barrow and barrio. Peculiar how the mind associates…

Fonda the Goat

Los Angeles, 1947

On Hobo Ridge a goat, demonic in appearance, is devouring a stack of books observed by two old men who stand nearby over a fire. Wentworth, a white beard hanging down to his knees, looks well over ninety. His companion Portnoy is a younger old man who chews tobacco and spits often.

WENTWORTH: Ha! The goat is a philosopher. She's eating Spinoza, she's eaten half of him already. She disdains, however, Hegel.

(His accent is nineteenth-century: he is well-educated, a Midwesterner reared by East Coast upper-class parents. There are shades of Jimmy Stewart. He is slightly tipsy.)

PORTNOY: Oh quit it, Wentworth. She just ate the newspapers too.

(He has a rural West Texas accent.)

WENTWORTH: No! No! She ate only the Herald Examiner. She disdained the Los Angeles Times. HA! I tell you, Portnoy, she's a radical. This goat is a radical-thinking goat!

GOAT: Meeeehhhhh!

PORTNOY: (dismissing and disputing Wentworth with put-on disgust) Ahhhooo!

LITTLE GABRI: (Seven-year-old Gabriela chases after her goat.) Fondaaaaaa!

WENTWORTH: Ah, here comes our little Heidiquita. Fresh-faced and barefooted in these, our Angelyne Alps.

LITTLE GABRI: Fonddaaaaahhhhhhhhh Ay yi Yi.

WENTWORTH: Hola, little Heidiquita. Your goat is a philosopher. I was doing my weekly burnings and—

PORTNOY: The Spanyo girl is called Gabrietta, Wentworth, don't tease the little one. (He leans down to Gabriela.) Hello.

LITTLE GABRI: Hi Mr. Edward. (to Portnoy) Hello Mr. Sam. (to Wentworth)

WENTWORTH: Hello child. Eh, well, since your goat has done such great service in dispensing with half a tiresome philosopher and all of a newspaper in one day I suppose I must render you a small payment. (holds up his arms) Where's m'penny?

LITTLE GABRI: Ohhh. Your knee pocket, Mr. Samuel?

WENTWORTH: No!

LITTLE GABRI: Ohhhhhhh. In your—in your watch pocket?

WENTWORTH: No!

LITTLE GABRI: Your vest p—

WENTWORTH: No—

PORTNOY: (interrupting) Give the kid her damn penny, Wentworth!

WENTWORTH: My beard. The penny is, is in my beard. Take it.

LITTLE GABRI: Thank you. I hide it or Fonda will eat it.

GOAT: Meeeehhhhh!

WENTWORTH: And what has your goat eaten thus far this morning aside from eh, uh—??

LITTLE GABRI: Oh, she ate eucalyptus buds, clover, grasses, she ate a Saint Michael cake from the nun's bakery—hee hee she wasn't 'spose-to—and um, she ate the jasmine from the Chinese's fence, um...

Miriam in La Loma

Los Angeles, 1947
Miriam's letter continues.

So I walked up the hill, my pumps covered in dust. The Mexican women—copperish skin, bodies angular and soft at once—stared at me silently from behind raggedy fences. They weren't at all like the 'Porto Rican' immigrants we've seen in New York since the war. My mission was to find this fellow Carl Pruit. He's an artist, mostly employed doing mechanical drawings for city planning, and he's volunteered teaching the local school children Art. The idear was for him to introduce me so that I could get a notion of their diets. Ruth Davies plans to do a food drive for them in Elysian Heights and fill any gaps in their nutritional schedules.

Hobo Ridge

Los Angeles, 1947

LITTLE GABRI: ...and um she ate the Negro family's thrown-away hat, she drunk from the creek—
WENTWORTH: Drank from—
LITTLE GABRI: *Si*, she drunk from the creek, and she ate two buckets of the Ortega grocery's garbage, and grasses and *yerbas* as usual.

WENTWORTH: Is that all?

PORTNOY: I was gwine t'say, sounds like it's been an awful slow morning for Fohnda the Goat!

GOAT: Meeeehhhhh!

GABRI: Hee hee.

They all laugh.

Gabri in the Gatocombs

Los Angeles, 2001

GHOST GABRIELA: Mmmm. I could really use a *fish* stew right now, maybe *un asopao de bacallao* like my little *Puerto Rican* daughter-in-law *Quiqui* used to make. Mmmm. But wait: I got a feeling. Something *tells* me that the dead can't eat! I've got a hunger, God. Tell me, why am I still hangeen around here, sniffin' for scraps?

Manny and the Pillow

Los Angeles, 2001

A young man lies on a bed in a pale blue room. He rolls onto his back, clutching his pillow.

MANNY: Aннн! This pillow has been without a case for how long? Two weeks. Aw, look at you, you soft gray piece of shit, you used to be a regular pillow, man. What happened to you, *ese*? (He has a fourth generation LA Chicano accent.) Pull yourself together! You losing your stripes! You look like *shit*, bro'!!

(He throws the pillow across the room, laughing.)

A ha ha ha ha ha.

Whew. All alone. *Mami*, *Papi*, *tias*, uncles, brothers, sisters, they all gone.

Grandmami dead in the kitchen for three days. What am I going to do? I ain't gonna get out of bed. No. I refuse. I *won't* leave.

LA Core-US

Los Angeles, 2001

Santa Monica. A woman talks to herself as she drives.

UPSET DRIVER: People never get out of the fucking way they get in your way that guy is just shoving into my lane how am I supposed to know what he's doing? He didn't signal. Die, asshole, die! See? This is how they drive. No, I won't let you in, not after that, you don't deserve it. Yep anh-hah! He's on a cell phone. I knew it! I knew it! What're you honking at? Oh, it's your fault fuck you fuck you it's your fault don't honk at me!

(Culver City. A Central American flower-seller stands by a freeway entrance offering flowers.)

FLOWER-SELLER: The sun in my eyes bouncing off the car plates, the asphalt, the plastic wrap bouquet sweating in my palm. Only two left. Sweat coming from the trousers my sister ironed this morning. It's too hot. Not cool like the mountains where I grew up, but down here by the freeway, there is always the sun, the auto fumes. Will anyone buy these last flowers so I could go home?

(He walks toward a car, offering flowers.)

Manny's First Time

Los Angeles, 2001/1997

Manny remembers.

MANNY: It was the time of my life the time of my life that night I first hit the scratch and spin. There I was a little skinny guy half *Mexicano* half *Salvadoreño*, fifteen years old in a shiny blue shirt my sister Izzy picked out for me down by Sunset at Moda Fashions.

She goes—Buy it! It's sick. You look like one of those slick, super-fly, Hollywood dee-jays—

An I go: Fo' real?

—Fo' real Fo' real Fo' real—

(He sits up in bed, swivels around.)

It was the time of my life the time of my life that night I first hit it in a Hollywood club down by Wilcox...

Fifteen years old in my shiny blue shirt, stingin' the turntables, pollinating the vinyls into blues into reds into pinks into yellows. Me, Manito, Manolo, Emmanuel, I was it—the blue charisma Christ, a skinny hummingbird whizzing them all past a crumb-bum club down on Wilcox, wrong side of Santa Monica, swayin' 'em in my dizzy loop above the hagged-out palm tree skyline, over the flowerpot roofs of those caramel candy houses and away in a beat that goes on and bleeds into all things and makes the president and all lies you ever heard *alright* and makes every cartoon and television commercial you ever saw *alright*, and makes jazz, blues, Taiwanese flute playing, Tuvan throat singing, reggae, sitar, hip-hop, bebop, techno, trance, *Tejano*, salsa, samba, classical violin, fruttati Liberace, the Beach Boys and the Buena Vista Social Club *alright*, makes the sounds of laundry drying, car-wipers wiping, babies crying, machine guns flaring, women groaning,

old men laughing, young men fucking, *cops cops cops cops cops*—
every damn cop thing they ever did *doing*, gates slamming, car
alarms bleeming, sweatshop sewing machines sewing, heavy
machinery thrashing, lawn mowers mowing *ALRIGHT*! And the
beat goes on and makes all of it—the synthesized, mad, crazy-
mad, sick, skateboard rush of it, as the sky opens up like a
diamond Lucy—four billion, gabrillion, zabillion ti-imessssssssss
alriiight.

At four in the morning there was twenty people left dancin' and
they didn't want it to stop but the club manager said to chill and I
came out too quick an' sat pretendin' I was kickin' it, smokin' a
blunt, tryin' to be cool. To regain it. My composure. Whatever.

(Manny lights up a cigarette.)

I packed up my vinyl and waited for this bartender lady to give
me a ride back to Echo Park. She had chopped-off white blond
hair—all punk rock—and that black raccoon eyeliner around her
eyes? She was about thirty or something. Old.

So we go to her car—it was dope, I must admit it—a '48 black
Chevrolet? An' she clears out the front seat—all this coats an' Thai
food take-out—the girl was messy—she piles the shit on all my vinyl
in the back and I get in. Liz, her name is Liz. She lives in Silverlake
with her old man, this musician.

(In a bathtub in Silver Lake, a punk-rock chick lights up a
cigarette, sinks into the bubbles, and remembers Manny.)

MANNY: At Holly 'n Vermont, she pulls over and she goes:

LIZ: Y'know…

MANNY: And she flicks the ash of her cigarette right onto this
naked doll she has glued to her dashboard. A naked Betty Boop doll!
Just like that: flick, ash.

LIZ: I'm all: Y'know, you think you're a deejay or something?

MANNY: I go: Huh? Excuse me?

LIZ: And I'm all: Well you're not a deejay, m'kay?

MANNY: What? I just got finish—

LIZ: (coughing and smoking) And I'm all: You're not only a deejay. You are MORE than that. You're an artist.

MANNY: Artist?

LIZ: An artist. You had us all in the palm of your hand.

MANNY: An' I go—Yeah. So? I'm acting all nonchalant but inside I'm going what the fuck is she talking about? I felt like a picture of Christ. All night long I was seeing pictures of Christ like in the little blue prayer book my other granny sent me from El Salvador. I go: You want to see the palm of my hand?

LIZ: And I go: Don't be a little prick. And he's all:

MANNY: Kiss it. She takes my hand and drags it across her lips. She reads my palm future with her tongue.

LA Core-US

Los Angeles, 2001

Miracle Mile

BUS LADY: God, please bring the bus. God, please bring the bus. God, let me be home soon. Take a shower. Bathe my feet, light a candle to your saints, God—*Kabunian*—make the bus come. Please I pray: where is the bus?

Miriam in La Loma

Los Angeles, 1947

The letter continues.

MIRIAM: I must admit to you Estie, that coming up the lip of the hill, with the birds seeming to sing extra loudly in my wake, coming upon a folding valley, limned in golden grass and green trees, hazed in sunlight, it certainly seemed the oddest sort of slum I'd ever seen! But Ruth Davies had already warned don't romanticize their poverty just because you find it quaint.

I suppose I may as well admit I don't much care for Ruth Davies. It has to do with the way she wears her hay-er. She has lovely silver and black hair and she shows it off to its least advantage. Here is hair that could be coiled in glorious braids or clipped back and worn long and luxuriant down the back, or even combed into a severe but dramatic knot, but Ruth wears it in a shapeless, sloppy hump atop her head. I find this pretentiously dowdy and it makes me dislike her. I feel like a secret rebellious child around her.

Incidentally, I myself have bobbed the red mop these days. I comb it so that it sticks out gamine-like from my freckle-face, I fancy I look a bit French gypsy. Enough about hair!

Gabri in the Gatocombs

Los Angeles, 2001

GABRIELA: Ay, these kittens think my hair is a ball of yarn. God, how much longer do I have to wait before you scoop me up and take me to heaven, the same way I would like to take and scoop up one of these pain-in-the-rear-end kittens? What is it, God are you trying to teach me some type of lesson?

Miriam Meets Little Gabri

Los Angeles, 1947

The letter continues.

MIRIAM: I stood in front of this classroom of tittering children, Ester. They thought my Spanish was ridiculous and I'm sure it was. They just stared at me and made me squirm as I faltered away, introducing myself. 'Hola. Mi yamo Seenyora Miriam Tromble. Mrs. Miriam.'

Suddenly, the entire project seemed foolish to me, as foolish as I felt. But then from the corner of my eye I noticed one little girl with bare, scratched feet—not even bad shoes, Ester, but simply, none, and I realized that Ruth Davies, for all her dubious dowdiness, was quite right—these children could be hungry. So I went up to this little girl and asked her to make a list out of *awl* she'd eaten that morning for her des-say-yoon-er. And they laughed again at my horrendous pronunciation of the word breakfast. This child, Gabriela, looked up at me, and her eyes were just like yours, Ester, dark and curious and rimmed in black lashes. She told me '*Esta mañana* I put in my belly: bread, carnation milk, white cheese and guava jelly.' She giggled and all of the children giggled with her. And suddenly, it became a game for all the children. They were racking their brains to make rhyming lists of all that they'd eaten. They raised their hands. I wrote it on the board. I felt so relieved, triumphant almost.

All in all I don't think their diet is so bad. I think they need clothing more than food, but perhaps a bit more fresh milk and meat would help.

Gabri in the Gatocombs

Los Angeles, 2001

GHOST GABRIELA: Am I being kept after school because I missed my homework? What is it, God?

LA Core-US

Los Angeles, 2001

East Hollywood. Two people wait in line at an Armenian take-away chicken establishment.

MAN: Ur, you know last year they had a massacre in one of these places.

CURIOUS WOMAN: A massacre?

MAN: Yeah, you, you know one of these Armenian chicken places they had a massacre. Uh, guy came in last year just started shooting everyone, just shooting everybody in the place with a machine gun. Yep. (guilty nod and grin) Lotta people were killed. Had a massacre.

CURIOUS WOMAN: Where was it?

MAN: Hollywood and Gower…Mini-mall you know, they got a pet food store, shoe repair. They got a, a dry cleaners, like that. I own property up by there.

CURIOUS WOMAN: Oh. It's still open?

MAN: Nah, nah the chicken place? Nah, they closed it down.

ARMENIAN COUNTER-LADY: Wread-dee?

MAN: Yeah. Ready. Uh, let me get, uh two whole roasted chickens to go? And a quarter chicken plate for here. All dark.

ARMENIAN COUNTER-LADY: Vombeee, twowholechickeentogo, qual-ter chickenplateforhere.

MAN: All dark.

ARMENIAN COUNTER-LADY: All dark. Ye-as.

MAN: Uh and two whole chickens to go-to go?

ARMENIAN COUNTER-LADY: Two whole to go. Ye-as.

MAN: And you're gonna gimme the garlic sauce?

ARMENIAN COUNTER-LADY: Yeas, that comes with.

MAN: But are you gonna give me the extra garlic sauce?

ARMENIAN COUNTER-LADY: Okay. I give you extra.

MAN: You got to ask for the extra—they don't give it to you.

CURIOUS WOMAN: Mmmhhhm. So how many people were killed?

MAN: Oh, it's your turn.

CURIOUS WOMAN: Oh yeah.

The Stadium

Los Angeles, 2001/1997
Manny and Liz remember.

MANNY: She drives a long ways up to the hills. High up past Stadium Way in Elysian Park and she parks. Ah, naw.

LIZ: What's the matter?

MANNY: My granma was from here. Ah, naw.

LIZ: What do you mean? This is a park.

MANNY: Yeah. Yeah, but she was from over that way.

LIZ: What?

MANNY: This is the stadium.

LIZ: So what?

MANNY: Yeah, you don't get it. My people came from there.

LIZ: Your people came from a baseball stadium?

MANNY: Never mind. You don't get it. Soldiers came.

LIZ: Soldiers?

MANNY: Something like that. Never mind. It's stupid. Let's go. We sit there. Finally, she starts the car. I change my mind: No, come on, get out of the car.

LIZ: Let's clear the backseat—

MANNY: No—no—you wanna? No, get out of the car.

We walk down to this little children's playin' area with a swing-set and from there I can see the stadium lights and some bleacher seats. I go: let's get naked.

LIZ: And he took off his blue shirt, his pants, his briefs and stood there waiting for me with moonlight on his hard-on and no shame. I'm all: Don't you know how to make love to a woman? You're supposed to undress me.

MANNY: I don't want to. Take off your clothes and see if I know how to make love to a woman.

Gabri in Lock-Up

Los Angeles, 2001/1959

GHOST GABRI: I lay like this on the floor when the marshals came and took us out. But not still like this, no, unh-anh, not quiet and still.

There I am, screaming and kicking at those marshals. I got in some good kicks, too. Uh-huh. I'm sure they resented that. They threw away our belongings when they had dragged me and *mi abuela la bruja* out. Part of our punishment for being some of the last hold-outs against the Dodgers when everybody else was gone, I guess.

I was in the county for three weeks, part-time solitary. Mrs.

Miriam Tromble sent me a letter. I never even read it. I used it to roll cigarettes—this Italian dyke girl gave me tobacco for licking her tits. I tore it into strips. I made sure not to read it. I rolled it carefully with the writing on the inside and then I smoked it. I never communicated with her at all.

Hannah

Brooklyn, 2001

A young New Yorker writes an e-mail. She is Jewish, raised on Long Island, but only vestigial traces of this accent remain. She has a somewhat flat, laconic style akin to certain "This American Life" commentators.

HANNAH:

DATE: 4–15–01

TIME: 04-colon-03-colon-52 EST

TO: Klugdude@globix.com

FROM: HaHaHannah@xerxes.net

SUBJECT: Terrible

Dear Josh,

I have horrible news and hate that it has to be conveyed in this most casual of information delivery forms, the e-mail. But my long distance carrier just cut me off. I bought a phone card from one of those little Arab bodegas but it doesn't seem to be operable. Maybe I ate up all the minutes angsting with Ian in Portland, I don't know—they sure don't give you as many minutes as they say they do! Anyway I have no way, right now, at four a.m. New York time to call you in Seoul where God knows what time it is in Korea and tell you what's happened. Terrible news. I'm stalling, I know.

Josh, Aunt Miriam is in a coma at Park Slope Methodist Hospital. She's in ICU. And the horrific part is that she was beat, she was beaten at Ebbets Field Housing Project by all these kids.

Oh Josh, I can hardly type. (She starts crying.) My server just disconnected me. SAVE! SAVE! SAVE! Shit, I have to reconnect, redial. I hate these things. I wish you were here in all your geeky little brother splendor to make things right, to hold my hand. I know you're making a hi-tech fortune out there in Korea, I know it's the only way I can cry on you right now across the oceans but I hate these things. I hate these—computers...Auntie Mir is all we have left since mom died. Sure, there's Dad down in Daytona with his nerdy wife but he's so utterly unable to have emotions anyway.

They beat her really bad, they beat little Auntie Mir to a pulp. Her face is torn. She has open wounds all around her trunk and chest, her legs are bruised a terrifying brown color. Medicare is shit. But the City Victim services may pay. Doctors were actually nice. Nurses let me stay. The *Post* was there. And News Four New York. I hope this doesn't blow up into some Crown Heights, Central Park Jogger case. No one's been charged yet. Cops were there but Aunt Mir didn't budge.

The Stadium

Los Angeles, 2001/1997
Manny and Liz remember.

MANNY: It takes her awhile to get her boots off. Then she sits on the swing and takes off the rest of the velvet and plastic she has on. She took off her panties and she was naked.

LIZ: I run my hands all down those young shoulders, those ribs, that ass, the backs of his hairy legs.

MANNY: I hold the chains of the swing and back her against it. It's hot. I'm biting into her like a melon. Then she raises up and catches the swing and wraps a leg on me. I have her sitting on the swing going in her like that. Oh it's hot in there.

LIZ: —and the stadium lights burned holes in the center of his eyes—

MANNY: She is all stretched out on the swing and she's my first real woman and I'm making her hot inside, swinging her back and forth, chain creaking, keeping one hand on her body...

LIZ: —Surrounding his cock in the park his eyes burning white—

MANNY: I am burning my cinnamon-colored, *El Salvadoreño*, *Mexicano* cock, from THIS barrio—no not Angeleno Heights—but my from THIS-barrio-in-THAT baseball-park-over-THERE's cock, my LA LOMA cock into this white, white woman, white as the moon—

LIZ: It was getting to be too much.

MANNY: We lay down in the grass and I go as far up as I can make myself go and she's calling and groaning... I could feel that ripple coming, I know I have to keep the beat going on and on and in her. Do I know how? Do I know how?

LIZ: The lights filled his irises.

MANNY: The baseballs popped a million home runs.

She is park, she is trees, she is a sticky cherry popsicle—my stinger leaps, my nectar spills. She's making me honey; she's pouring out honey. It's here in the valley of white, white light I drown sorrow's soldiers in the milk we make. It's alright. It's alright.

LIZ: It's alright. It's alright.

MANNY: That was Liz. My first woman. I never saw her again.

Hannah

Hannah's computer dials up, squawking and farting as it re-connects on-line.

HANNAH: I'm feeling better now. Back on-line, having some mood-mender tea. Celestial Seasonings. Josh, if you're worried she was raped, she wasn't. Get this—and the cops have three witnesses they told me have all stated this—her attackers were all girls. Little 12-year-old black nigger monster bitches attacked her. Delete! Delete! Delete! Delete! I said something racist and deleted it. Yes! I feel racist! I feel angry! I know Aunt Mir would hate me feeling this way. She'd probably staunchly deny that her attackers were even racially motivated, bless her deluded leftist soul.

Why? Why did they attack a little ancient Jewish lady who's only foolish enough to be in their neighborhood because she's spent her whole life trying to help?

On the good side, I have to say that Mir still looks—well, how to describe it? I lay next to her all night and her soul was very vivid to me. I think she has a chance. I pray. I know you're an atheist—Aunt Mir too—but I'm going to find a rabbi first thing in the morning, right after my triple grande latte. I need solace and you're not here. Call as soon as you read this or sooner.

Love, Hannah

Send!

The Curtains

Los Angeles, 2001/1959

GHOST GABRIELA: When I came out of the county I had to stay in this stinky apartment on Kensington with my sister Gladys and her husband Armando. I shared a room with my three little *sobrinas*. Gladys had hung up these Snow White curtains but they had a stain on them—like a brown discoloration? Why she didn't take them down? Anyways, I would lay on my pad on the floor, just drifting in my thoughts and there was a breeze from the airshaft that blew over my face. These curtains would tickle my cheek passing over me and I imagined I heard Mrs. Miriam whispering, 'Gabriela you are an imaginative girl. Gabriela, Gabriela, you could be anything anyone who you want to be.' Well. That wasn't how it turned out. I remember the smell of souring baby bottle formula and cauliflower. Armando was helping sell cauliflower off trucks by the freeways on the weekends. So they cooked cauliflower constantly; they had boxes and boxes of the stuff. I wanted to go back to jail.

Ghost Gabriela closes her eyes, willing her thoughts silent, ready for God to take her away.

Manny Wakes the Dead

Los Angeles, 2001–1947
Manny runs into the kitchen and throws himself on Gabriela's body.

MANNY: *Abuela*! *Abuela* Gabriela!

(He lifts her up and puts her on the kitchen table.)

GABRIELA: Ah! Manny! Finally! What are you doing? Get your skinny fingers off my *culo*! What, where are you putting me? On my table?

MANNY: (Runs back to his room and seizes his record collection and turntables, staggers into the kitchen and dumps them on the kitchen table.) AHHHH I could feel it hummin' on, like a phenomenon, like I need a fix only it's a new mix comin' on. (He leans against the refrigerator, shaking, then takes a deep breath and rights himself, stumbling over to the records he's just dumped on the table.) Yeah, yeah here goes my whole damn vinyl selection here.

But, naw, naw, it hits me now! Where is *her* record collection? Oh. She has one alright; it's like the whole entire family's.

(He runs into the living room and rips opens a huge, bamboo
record cabinet, kneels down and starts tearing out records.)

GABRIELA: Manny, don't you *dare* set foot in there! You *better* not be messing up my living room! All these—all these records what is he doing? Why's he got his turntables beside my hips?

MANNY: (He runs back and forth between the kitchen table and living room record cabinet, thumbing through armfuls of records.) Aw yeah: Uncle Mike back in his doo-wop days and her with her Tito and Johnny Rodriguez, *Bis-Abuelo's* oldschool *corrido* ballads then those farmworker *tias* with Lydia Mendoza—ah yeah! that shit!—Granpa Frank's newschool *Tejano* with the bad synthesizers and the yelping, and then *Mami* loved all those straight up crooner ballads: Julio Iglesias and all that bunk...

(He dumps the first load on the table.)

MANNY: Yeah, uh-huh, and then—some of the sisters they're so old they still like Led Zeppelin an' Santana and shit. And then—yep—*Tia Quiqui* left behind all these *salsa merengue* people and Ritchie Valens. And then—here's this shit from the 40s and 50s—weird shit—I don't know know where she picked it up—white people singing folk songs, jazz, war songs from Spain and—

GABRIELA: Look, I'm sitting up. Manny! This is my old kitchen. It's the old lime-green linoleum from '59 when I first moved here with Frank. Oh look, I can walk now. (She stands up and starts taking jerky, unsure steps. She enters a wall.)

Oh gre-whup! This wall. Euuh, it smells like old spiders and decaying mice. Euuh, all those poisons I had Mike stick inside here in the 70s! Smells terrible. I want to get out of here. Ah, the hall-way. Oh, it's the 60s, we used to have it that custard yellow in the 60s, me and Frank… *There's* Frank shaving. Frank?

(Frank doesn't see her.)

Oh-oo. *I* get it—these decades are thinner than the walls. I can walk through anywhere.

(She walks through another wall and heads toward the living room as Manny begins to spin his vinyl.)

MANNY: This is gonna be the mix of my life.

GHOST GABRI: (arriving at her sofa) I can walk anyplace.

MANNY: This is gonna be my *grandmami* funeral mix.

(Miriam's letter continues.)

MIRIAM: I decided to walk home the other way. Through the Elysian Park and out along Park Drive. I had to scale two ridges. (She walks.)

MANNY: I'ma embalm her in samples of my music.

MIRIAM: There's a curious settlement of old bachelors on the first ridge, living in a whole series of ramshackle lodgings seemingly held down only with twine and wire.

MANNY: —wash her feet in rhythm, oil her hair in song—

MIRIAM: I stopped there (she sits down) for a rest and met the proprietor—a very old and literate man called Wentworth. He intro-duced me to a Texan by the name of Ed Portnoy who seemed quite annoyed by a third man they called Dreyfus.

(She stands up and leaves.)

Dreyfus had constructed a huge religious sculpture on the ridge rigged out of fishwire, popsicle sticks, clothespins, dolls—

MANNY: Sing her soul to—mooga mooga scratch—

(Manny scratches and spins her backward in time.)

MIRIAM: (she walks forward again, repeating)—a huge religious sculpture on the ridge rigged out of fishwire, popsicle sticks, clothespins, dolls—

MANNY: —Mooga mooga—scratch—

(Manny scratches and spins her backward.)

MIRIAM: (repeating and walking forward)—fishwire, popsicle sticks, clothespins, dolls—

MANNY: Scra-atch her—not to sleep but to zombie sound.

(Manny spins it forward.)

MIRIAM: —and other debris.

MANNY: Into—into the night—wake her to walk with the dead!

MIRIAM: The sculptor Dreyfus seemed quite out of his gourd but perfectly harmless.

Manny listens as he lets a song play out.

Hobo Ridge

Los Angeles, 1947

DREYFUS: (Writing on a doll's butt beside his junk sculpture.) GOD IS NOT LOVE.

PORTNOY: (He tips his hat to Miriam as she recedes, then spits on the ground, kicks dirt on it, and walks over to Wentworth who is sitting on a crate.) Now what that lady don't know, I meant t' tell her is that—

DREYFUS: —GOD IS YOUR IMAGINATION BACKFIRING ON YOUR BURNING BUSH—

PORTNOY: Oh will ye shut UP! Look at him scratchin' his sick little religious poem on that poor dolly's rear-end.

WENTWORTH: Don't be too hard on him, friend. You were saying?

PORTNOY: What that lady don't know, I meant t' tell her, is that yuh cain't just say thar's poor. Thar's two types o' poor: thar's the CLEAN poor and thar's the DIRTY poor. I myself came out of West Texas from the DIRTY poor.

DREYFUS: (gives Portnoy a paranoid look) Heyyuhhhh

PORTNOY: (in exasperation) Ohhhhhhh!

DREYFUS: Huhhh! The devooo! (glares and returns to his obsession) Write on da dolly's butt…mmm…

PORTNOY: (spits in the dirt and continues) Since then I've turnt clean and I've worked my whole life with my hands and on m' feet and I've seen that you can't just call people POOR. Here on this ridge among our number there are the DIRTY and the CLEAN, and in our neighbors in the valley and the hill there are the DIRTY Spanyos and the CLEAN. That's why somebody should tell that Lady you cain't just say poor. There are the dirty and the—

DREYFUS: I shee it comin'. We all goween to be cwushed—

PORTNOY: Ohhhh. Will ye shut up!

DREYFUS: CWUSHED BY A DIAMOND!

PORTNOY: Now what in BLASTED hell is he on about!!? Go on! GIT! Climb on up yore crap-heap! Git!

DREYFUS: (climbs his sculpture) Cwushed by a diamond. Cwushed by a diamond. We all start off coal but from wonteen fings so much it cwushes us cwushes us to a diamond shape.

MANNY: I'mna lay every last one on every track down…

DREYFUS: Diamond shape. We all going to be fwattened here to a diamond. Diamond shape: Snakes above an' below, snake road snake road every place, Seven double ones, I see dem comin, I do, I do!

BUS LADY: Where is the bu
—where is the bus where is
Where is the bus? Where is
When will it ever come come

MAN: But are you gonna give me the extra garlic sauce?
LADY: Okay. I give you extra.
MAN: You got to ask for the extra—they don't give it to you.
CURIOUS WOMAN: Mmmhhhm. So how many people were killed?
MAN: Oh, it's your turn.

DAMON: Shut yer mouth, duuude.
RANDY: Listen to this and somebody come feed us...

UPSET DRIVER: People never get out of the fucking way, they get in
your way. That guy is just shoving into my lane. How am I supposed
to know what he's doing?
—he didn't signal. Die, asshole, die! See? This is how they drive.
No, I won't let you in, not after that you don't deserve it, Yehp ah ha
he's on a cell phone. I knew it! I knew it! What're you honking at?
Oh, it's your fault. Fuck you! Fuck you! It's your fault don't honk at me.

I wish I had taken off my orderly shoes and put on r

bring the bus. God, let me be home soon. Take a sh

God—Kabunian—make the bus come. Please I pray

ere is the bus—
bus where is the bus?
bus? Where is the bus?
ne come come come...

RANDY: Wer sooo hungry

DAMON: I know. We are? Wer like on a desert island heur?

RANDY: Yeah, we need some sweet lady whuese listening out thur to bring us sum feeeuuud?

CHICKEN RESTAURANT

MAN: All dark.

COUNTER-LADY: All dark. Ye-as.

MAN: Uh and two whole chickens to go—to go?

LADY: Two whole to go. Ye-as.

MAN: And you're gonna gimmee the garlic sauce?

LADY: Yeas that comes with.

ENTRAL AMERICAN FLOWER-SELLER BY FREEWAY ENTRANCE:

he sun in my eyes bouncing off the car plates the asphalt

he plastic wrap bouquet sweating in my palm. Only two left.

Sweat coming from the trousers my sister ironed this morning. It's too hot.

Jot cool like the mountains where I grew up, but down here by the freeway,

als. God, please bring the bus. God, please

here is always the sun,

athe my feet. Light a candle to your saints,

he auto fumes.

is the bus?

Will anyone buy these last flowers so I could go home?

MANNY: Fuck that it's-a-small-world-after-all amb
trance shit, I'm gonna smack a mega mixicana w
upside the head of any foul mother grandmother f
er who wants to slit my viva la raza throat. Yi-ah!

Boom Lay it down.

and bleeds into all thir
president and all lies y

LA LOMA, 1950
CHAD: You tell your Dad that we are going to purchase—
'compro' as you say. We are 'compro'ing the house here and all
the houses around here and building a Public Housing Project.

makes every cartoon
you ever saw alright,

MR. ZORRITA: (shakes head) Que dice? Publico House?...

and makes jazz, blues
tuvan throat singing, r

hip-hop, techno, tranc
classical violin concert
the beat

FLATBUSH, 1955

RICHARD: Catch it! Catch it! Aw shit, you stupid bastard, now we're goin ta lose it! Damn it all!

DAVEY: Hey, don't talk like dat tuh me!

RICHARD: Why not? It makes me sore you di'nt catch da ball!

DAVEY: Aw, I hate stoop ball anyway. We oughtter call it stoopid ball. It ain't no fun.

RICHARD: You can't take it, you dumb hebe. You ain't goin' ta make it to the Dodgiz like me.

and makes the
ever heard alright and

television commercial

Downtown Manhattan, 2001

JAN: Uh you're listening to WBAI. I'm Jan Weismann. We're taking cwualz about the Ebbets Projects Case. Hello, 'Tawk Yur Head Off,' you're on the ay-er.

(Whispering)

iwanese flute playing,
ae, sitar, bebop,

DAVE: Did you ever go, Jan? See the games there? See the Dodgers play?

JAN: I hate to tell you Dave but I never gave a beep about baseball—or any sports for that matter. Do you want to talk about the case?

DAVE: Wasn't I?

JAN: No. We're going to have to move on.

ejano, salsa, samba,
fruttati Liberace goes on ...

the Beach Boys and the Buena Vista Social Club alrigh

makes the sounds of: laundry drying, carwipers wiping,

babies crying, machine guns flaring, women groaning,

old men laughing, young men fucking,

cops cops cops cops cops—

(PAUSE)

CARO: Chucho and Gabriela and her abuela and one other family with a
tall daughter was the last holdouts.
VIVI: Yeah, they're the ones that got on teevee.
CARO: Gabri was on too. They drug her out wearing that plaid shirt and
kicking with those boots.
VIVI: No, that was the tall girl.
CARO: The tall girl was Gabria.
VIVI: No that was another family.
CARO: How do you know? Your family was practically the first to leave!

every damn cop thing they ever did doing,
gates slamming, car alarms bleeming,
sweat shop sewing machines sewing,
heavy machinery thrashing,
lawn mowers mowing alright

MANNY: (raises his volume)
and the beat goes on
and makes all of it
the synthesized, mad, crazymad, sick, skateboard rush of it,
as the sky opens up like a diamond lucy, four billion gabrillion
zabillion timessssssssss alriight.

Echo Park, 1986
VIVI: Was there only three holdouts are you sure?
CARO: Who else?
VIVI: The Johnsons? The black family?
CARO: No, they I no, they left, they wheeled their juke-box downtown remember?
VIVI: Yeah?
CARO: There was some big mess...
VIVI: Yes?
CARO: It was those hobo men. That big tower of basura that old white hobo man made. He held out. He climbed up it. Wouldn't come down.
LITTLE MANNY: (getting a haircut) What happened?
VIVI: I don't remember.

Forest Hills Queens, 1996
OLD GUY: I remember it like I remember the day Jack Kennedy got shot. Someone's kid brother comes running up says the Dodgers are moving to Los Angeles. Walter O'Malley is moving the team out West. It is confirmed. We were stunned.
There was something people said after that. The three most hated men in Brooklyn: Adolf Hitler, Joseph Stalin, and Walter O'Malley. And we weren't kiddin'.

Upper West Side, 1976
ALAN: I think that's when I first realized that there's a futility to life. Like no matter how hard you hit the ball or he, your hero hits the ball, it ain't going nowhere; it's a finite thing. There's a ceiling to the sky; there's asphalt for your playing field.
The world is not kind.
Everything is not possible; America is not always great. Finito.

s Angeles, 1947
REYFUS: Cwushed by a diamond. Cwushed by a amond. We all start off coal but from wonteen fings so uch it cwushes us cwushes us, to a diamond shape. amond shape. We all going to be fwattened here to a amond. Diamond shape snake. Snakes above an below, ake road snake road every place. Seven double ones, ee dem comin, I do, I do!

Los Angeles, 2001

MANNY: Yi-ah. Boom, lay it down, around, around it go, here come the accordion—troink!—slap a siren inta dat—wahhhhhh— and a helicoptor chopper—scra-atch—back to the mariachi, guy on a burro, ay yi yi type shit. Hmm, 's kind of pretty *que linda. Escucha…*

GABRI: Gee, look, I can stand on the windowsill. Practice flying like I used to when I was three years old with the boys next door on Calle Azulejo. Stick out my arms, like a zombie in one of those Mexico City horror movies and just kick off my heels. And fly!

(Gabriela flies out the window.)

MANNY: Beat, beat!

BUS LADY: Where is the bus?

MANNY: And the beat goes on…

Hallucination Map:

Brooklangeles

Coney Island Easter

Brooklyn, 2001

Chuck, a police detective in his mid-twenties, and his partner, Richard, a detective in his late fifties, question a suspect at the NYPD precinct in East Flatbush, Brooklyn.

CHUCKIE: So Angela, Yuh tellin' me yuh weren't at Ebbets Projects? Yuh tellin' me you wuhr'at Coney Island all day?

ANGELA: I was at Coney all day. Coney Islan' Eastah.

(Although there's something manic about her, she starts the interview off calm and truculent. Her accent is Brooklyn African-American, with a hint of Puerto Rican.)

RICHARD: Yeah? Tell us tell us about that day Angela De Mayo, Miss Angela Samantha De Mayo, tell us about April Fifteenth, two t'ousand an' one.

CHUCKIE: Do you lie as good as yur brother and yur Papi and yuhr who-ah sister.

RICHARD: Oh yeh dat's right! She's got a, a prostitute sistah. I forgot. Too many criminals to keep track of in the De Mayo clan.

ANGELA: Clan clan Kluck kluck klan.

CHUCKIE: Shut yuh mouth.

ANGELA: I'm tryin' but you interrorizin' me.

RICHARD: Aw, are you scared, Angela?

ANGELA: You ever eat a chocolate ice cube?

CHUCK: What?

ANGELA: Well you did now. I'm like that. I'm smooth. I'm cold. I don't melt.

CHUCK: Awright. We wanta know about Coney Island.

RICHARD: Yeah. Dat's all. We have a curiousity. We don't go there no more. Not since we was kids.

 (tries to exchange a look with Chuck who doesn't respond.)

ANGELA: I took a cab.

RICHARD: Oh ho—oh! You took a cab!

CHUCK: Yeah well you know she makes alot of money with her little pack of bitches, dealing.

RICHARD: Write it down, Chuckie. You got da receipt?

ANGELA: Where's my welfare? I want my welfare. I-don't-want-you-to-write-it-down!

 (As the interrogation picks up steam, Angela begins to speak incredibly fast.)

RICHARD: You don't need a social worker.

ANGELA: I'm thirteen.

CHUCK: That don't matter. Look what dey did to that old Jewish lady. Put rocks in huh mouth.

RICHARD: Hey! You're not charged. We just want to hear a story about Coney Island.

ANGELA: I took a car service.

RICHARD: Oh—Ho—oh! Now it's a *car* service!

ANGELA: It was always a car service.

RICHARD: You said a cab.

CHUCKIE: What time was it?

ANGELA: Uh, five o'clock. I took a livery cab.

CHUCK: What time was it?

ANGELA: It was dark. Starting to rain. I took a cab. You want to know my Coney Island Easter? You want to know my Coney Island Easter? I got out the car. I slam the door. There was ten thousand people there with they kids. Black people mostly.

CHUCK: Black people—what is she?

ANGELA: I'm Puerto Rican. *Soy Boricua!*

CHUCK: She looks black.

RICHARD: She's looks half-and-half. She's dark.

ANGELA: There were black people—ten thousand of them with their kids. Maybe they was one thousand *Boricuas*. Maybe one hundred whites. It was full-up—all the space between the rides was filled with people. People was dressed up for Easter. They had their babies dressed up.

Babies in bright-ass pink, babies in bright-ass blue, babies in bright-ass yellow. They hair in cornrows with beads and balls all done up. One baby by the blowups on the stick—you know the blowup balloons on a stick?—on the boardwalk? She was all in white —so cute, the cutest—and her mommy said: Monkey, monkey come here monkey.

(Richard and Chuck exchange a chuckle at this, making ape gestures. Angela ignores them and drives herself further into a channeling reverie.)

ANGELA: And it was ten thousand people partying down! I was all alone. I walked around and around. There was music—loud-ass old school jungle music—goin' on the, the rides where the cars go around and bump—the glitter cars? And there was food. There was hot dogs and stripety lollipops, yellow pistachio flavor ice cream and there was meat on a stick and melon on a stick, there was crinkle potatoes with ketchup in a cone and corn on a cob, and there was

clams and Nathan's hot dogs, hamburgers, and fried fish an' pizza slices and cokes and Pepsis and on the boardwalk there was beers and there was the funnel cake?—They make it fresh, they put it in the hot grease? —And I wanted some of dat! I wanted some funnel cakes! But first, I had pizza, and I walked around. They was stuffed brown bears with yellow ears you could win by throwing balls in nets and they was old school pictures on the walls of clowns. An' it was ten thousand people there and the rides was full up: the Wonderwheel and the Cyclone, the Pirate Ship—that swing!—the Hell Hole and the upside down shake you up ride. I rode the Cyclone four times and I held out my arms like dis—AHH AHHH AHHH AHHH!! No fear, there's nothing you can do to me ain't already been done. I'm cold. I'm smooth. I don't melt. I had some pizza and I walked around and I came outside the Snake-Lady tent. It said:

Ladies and gentlemen, please look inside. Inside we have a real, live Snake Woman. This is not a film, a photograph, or a picture. This is a real live woman with the head of a lovely young girl and the body of an ugly snake. No bones, no arms, or legs in her body. (Her attitude becomes mechanical as she adopts the voice of the tent loudspeaker.) Ladies and gentlemen, please come inside and see the head of a lovely young girl with the body of a hideous snake. Ladies, gentlemen, please come inside; this is not a film, photograph, or picture. Inside see the real live snake-woman, with the head of a lovely young girl, and the body of a hideous snake. She has no bones, arms, or legs in her body; she is a real live, lovely young girl, with the head, of a lovely young girl, and the body, of a hideous snake—

RICHARD: Hurry up!

ANGELA: —Ladies and Gentlemen, please come inside, there is a real live Snake Woman—

CHUCK: Yeah, yeah, hurry up, hurry up with the fuckin' a Snake Woman!

ANGELA: —you will see a lovely young lady with the head of a lovely young girl and the body of a hideous, ugly snake, no bones, or arms at all—

CHUCK: Would you hurry up! Hurry up! Okay, you said Coney Island, what time, what time was it?

ANGELA: (she responds in her own voice) It was six, it was dark, I was eating pizza, I was watching the woman outside the Snake-Woman tent collect the money, it was a lady with dyed-blonde hair wearing a army jacket, she was collecting five dollars apiece to go and see the Snake Lady.

(She lapses back into loudspeaker mode) Ladies and gentlemen, please come inside, inside you w—

CHUCK: Hᴜʀʀʏ ᴜᴘ!

RICHARD: Ain't over 'til it's over, Chuckie, let 'er finish.

ANGELA: So then I was walking along, I-was-walking-along and I wanted to have some funnel-cake. I wanted some funnel-cake, so I stood in line, I stood in line at the funnel-cake. And you know, they make it fresh? So I had to stay a long time and they pour it fresh, in the grease, you know, they pour it fresh? And then there was a Jamaican son, he had a camera, and he was shootin' it—he had a palmcord camera?—you could look through the viewfinder, you could see what's going through the glass pane, and you could see them pouring it fresh in the fat, and it curls up in the fat, the batter you know, it's like a fence. It makes a criss-cross fence, and it curls right up in the batter. And I was watching and there was a lot of people waiting in line and I watched a woman, she was beating her son against a car and he was trying to hold himself, and he was hiding under his baseball cap, and she took out her belt, and she

was like this 'ugh! ugh! ugh! Don't hide from me! Don't hide! Ugh ugh ugh ugh!' and then he ran and she ran—

CHUCK: Goddamnit she's like a fucking... She's mental. She's like a fucking transistor radio. Shut the fuck up.

RICHARD: Aright, just take the statement there, Chuckie.

ANGELA: And I stayed in the line. I stood, and I watched the little boy. He came back. He stood, and the mamma came back, too, and her face was all happy and smooth like she was on a ride, and she was walking real slow like she went on a real good ride, and he was standing, just standing, just waiting, just waiting between all his aunties and his big sister-women and they stood all around him, and the tears were coming down his face, down his black face. He had little diamond teardrops coming down his black face, and he cried like this...(crying, hiccuppy)

CHUCK: Ah, she's giving me a fucking headache!

ANGELA: And I stood, I stood in line 'cos I wanted that funnel-cake, so I stood. I stood, and then there was a boy, there was a boy, he tried to cut in line, and he was wearing a bright-ass, bright-ass, bright-ass yellow shirt, and he had a do-rag and a little earring in his ear, and these college girls, they called him out, these light-skinned college girls, they called him out, they said, 'You wearin' a *bright*-ass yellow shirt, and I *didn't* see you in line, so *step* back!' And he said, 'Well, I'll, I'm-onna-get-you, I'll take you out, m'onna take you out, you wone know, you wone know, you wone know!' But then he went away, he went away, he ran away. They said 'Look! Stupid! Cowert! He *ran* away. He couldn't even speak! Did you hear him? 'Gluh, gluh, gluh,' he couldn't even *speak*!' And then they got their funnel-cake and I got my funnel-cake and you could have, um, three different kinds, you could have pineapple topping, you could have it with strawberry or cherry topping, or

just plain with sugar? I had mine with pineapple topping and then I ate it and then I threw up.

(She abruptly stops. Silence.)

CHUCK: You threw up. Why'd you throw it up?

ANGELA: It was cold, it was starting to rain, people were fighting and I threw up.

CHUCK: Did people see you throw up?

ANGELA: I don't know.

RICHARD: Uh-huh. And then what happened, Angela?

ANGELA: I went home.

RICHARD: You took another livery cab.

ANGELA: Naw, I took the B train.

CHUCK: Oh you did?

ANGELA: I dee-id.

RICHARD: You meet anyone on that B train?

ANGELA: (thinks a second, seems to remember) Yeah! I met a little kid named Kahlina Shannon and her granmamma. And the granma told me that the child prefer to be called Destiny's Child.

CHUCK: Dat's it?

ANGELA: That's it.

(She is silent.)

RICHARD: You can go Angela.

ANGELA: Ain't you gonna drive me home?

RICHARD: A tough little cookie like you?

CHUCKIE: An ice-cube? No. Take a car service. Ha!

ANGELA: Alright, I will.

(Angela stands up, drawing her jacket hood up, Richard blocks her way.)

RICHARD: She's scared. Angela, you scared? What scares you Angela? You do something? You see something?

ANGELA: No, I pass out at night.

CHUCK: Cuuckoo cuckkoo. Whoo-hoo whoo-hoo.

(Chucks walks away in disgust, circling the "crazy" sign with his finger at his temple.)

ANGELA: I see the men running and the people scream happy screams.

CHUCK: Not like that old Jew lady who got beat by you and your friends. She wasn't screamin' no happy screams.

ANGELA: No, but it happens there in the middle.

RICHARD: What?

ANGELA: I been seeing it since I was little jumpin' rope. But the picture is gray.

CHUCKIE: Get her out of here, she gives me a headache.

RICHARD: Bye Angela De Mayo.

(He steps aside.)

ANGELA: (She leaves.) Goodbye.

RICHARD: You know what depresses me? I useta go see ball games where dat little freak lives. Ebbets Field.

CHUCK: Now you're datin' yuhself. I wasn't around back then.

RICHARD: Yeah? Dat was like the beginning of the end fuhr me. The neighborhood feeling died at that point.

CHUCK: Yeah? I don't know. I'm from the Island.

Richard gives Chuck a look; Chuck doesn't notice.

Marigold Nights in La Loma

Los Angeles, 1949

Miriam and nine-year-old Gabriela, sit together on the Zorrita family's rose-covered front porch. Miriam transcribes as little Gabriela tells a story.

GABRIELA: *Maravillas de papeles.* We have paper marigolds we make and we stack them with real living squash blossoms on the table. Then we write our prayers on round pieces of scrap wood, raw scraps with the bark still on. My *Papi* finds them at the lumber mills. We put up pictures: it could be prints or frame pictures, it could be a decorated *muñeca* of a saint in a box? Or, it could just be the lady on a tomato can. You know? The pretty Italian lady in green and red from the tomato cans? My *Papi* brings them from the cannery. Then we put up our favorite saints and *Jesus* and the Virgin. I don't think we ever have an altar without *La Guadelupe*. She is always included.

I like to feel her cheeks for hot tears. Uh-huh! Sometimes at night, I get out of the bed from my sister, walk there in the first room where my parents are sleeping, put my finger right *near* her cheek—not *on* but *brush* it right along and my finger gets a tiny pah! of heat like a heartbeat and I swear I feel those hot wet tears and my own eyes get wet. I use my other finger on my other hand to taste the salt from my tears and then, suddenly, I have to pee.

Hee heee can I say this Mrs. Miriam? It is not *malo*?

MIRIAM: I'm writing it Gabri, don't worry. It's our secret. We'll fold it up tight. You can say what you want in writing.

GABRIELA: This always happens. It might be I wake up in the first place because I have to pee.

MIRIAM: And you think this is just a whole routine that goes on with it?

GABRIELA: I don't know. We have an outhouse but that stinks bad.

MIRIAM: —Badly—

GABRIELA: Mm-mm, real bad. So, at night, with only one streetlight way down on the other side of La Loma and no streetlight at all here at the end of Calle Azulejo, I like to pee in the dirt

by the garden. Hee hee!! I squat on the other side of our fencepost garden. It makes a good smell in that night-time dirt and *los animales* are all around with their sounds and over the hills the trains in the yard make their noises humming. And then, on the train whistle through the hills, that yellow water comes out between my knees. Hee heee! It gets mixed up with the straw grass smell, salt tears, the paper marigolds and the living squash blossoms in my head.

An' I'm thinkeen: Tomorrow gonna be a festival day. Visits and food. Puppets and food. Music and food. Nuns and food. Me and Carolinda and Vivi are going to eat so much we going to get siiiick! But right now, all by myself, I pee in the ground under a dark cloth sky that *mi abuela* say is like a piece of fabric waiting to be embroidered.

Is this okay to say Mrs Miriam?

MIRIAM: It's lovely. What shall we call it?

GABRIELA: I don't know. You pick a name.

MIRIAM: Okay. Um. How about Marigold Nights?

GABRIELA: Yes. Okay. Fold it up.

MIRIAM: We will. It can be secret as long as you want.

GABRIELA: *Bueno.*

MIRIAM: Bway-no.

Bumstew

Los Angeles, 1954

Wentworth rises from a group of hobos assembled around a pot of stew over an open fire. He calls to the approaching Portnoy.

WENTWORTH: Ah, here's here's Portnoy—Portnoy, Portnoy my good companion, you've returned from playing in the moving pictures. Join us.

PORTNOY: It's called plain old movie, Wentworth, this being 1954 and you know I'm just an extry. I'll have my own dinner, I thank you.

WENTWORTH: Well now, instead, add it to the pot. We here among our peripatetic assembly are making a stew...

HARLIP: (like the other hobos, he doesn't particularly like Portnoy or Dreyfus) No need, we got enough.

WENTWORTH: Yes, well, nevertheless, em. Yes, Cunningham's put some bacon in, Harlip's brought a good can of tomatoes from his cannery works, and em, uh, hmm, Greeley's put in some potatoes and wine.

PORTNOY: And you, Wentworth?

WENTWORTH: (vaguely) Eh, well I'd planned on offering some of my homeopathic treatments after our me—

PORTNOY: You sir, are inviting me so as to take joint credibility for my contribution. As per usual, you wont a part of my franks 'n' beans plate.

WENTWORTH: (turning away) Very well. Go on. It's a shame... There's whiskey. Mr. Brinks found a case of it.

PORTNOY: Now, hold yer horses! I'll jine ye straightaway.

(Leaves to go get his can of beans from his shack.)

BRINKS: Huh-huh. Look at Dreyfus.

HARLIP: He's climbin' way up deh.

WENTWORTH: Tying on his latest artifacts of our present world. What's he—

HARLIP: Motahcycle wheel.

PORTNOY: (returns eagerly, breathless) Here it is, pry 'em right open and just dump 'em here in the pot. Whar's th' whiskey? (gets it) Ah!

WENTWORTH: (calls to him) Be careful climbing, Mr. Dreyfus, there's a wind tonight.

DREYFUS: The wind, the wind carried me here and the wind shall take me away. The wind of god thet blew that tent down.

WENTWORTH: He's referring to the revival tent; his parents were snake handlers in the Pentecostal tradition.

PORTNOY: There you go decoding him agin—what are you, his biographist? Fixin' to write up *The Chronicles o' Dreyfus*, dribblin' fool maniac of Hobo Point?

WENTWORTH: No, I was merely pointing out that his dementia is related to his overly religious upbringing which, due to his lack of exposure to atheist ideas, has—

PORTNOY: (cutting him off with disgust) OHWUH! Look at that darn fool go! It's a wonder he don't fall off his creation of shit.

DREYFUS: (high up in his sculpture) Green, in the green bower the serpent waits. They took me to the tent. No! No, momma no no don't make the snake crawl on me, no! Please, maam, please pappy, no no not the snake—AH! The write on you dollie is to prove that, to prove that the snake tongue makes sense, 'cause the serpent it stunk me, the serpent in the tent wrapped around and bit my neck. But Jesus kept me going to build this tower of New Babel, to babuild this from the garbage of the unclean and make it clean and healing. Ow momma don't put the serpent on me. AHHNHHH! (In his father's voice.) 'Ah, the serpent stings the boy he has sinned. Tell us your sins, Delbert Dreyfus, what have you done you are stung!' Ah! AH! Help me, help me! I am stunk! I am stunk! It hurts. I can't feel my frooooooat: water water. (In his mother's voice.) 'Confess to the preacher and Jesus will save you, confess it, Delbert.' I did I did a picture a picture of a girls butt. I did a picture of the cheeks and showed it to Sam-well and Edward—Mr. Po'noy, Mister Wentworf. No, no, that was then, this is

now and on and on, it don't make sense, it never did. Where are we now? I can see the teeth tearin' it all down, the hills ripped asunder. The wrath is comin' upon us. The tower of Babel shall fall before it can heal!

WBAI

New York City, 2001

JAN: (while eating a large sandwich) Uh, okay we're taking cwaulz, uh, about the Ebbets Housing Project Case, which, uh, New York's finest uh, racistly refer to, uh uh as the, Black Sunday Case, okay uhhh, which we all know is because the beating occurred on Easter Sunday, and because Ebbets Projects is in the Flatbush area uh, and—although no one in East Flatbush, uh, has been arrested or convicted of anything—nonetheless New York's finest, uh popularized this term, gave it to the *New York Post*, because many of the people there uh, happen to be, People of Color. (Burps loudly) Excuse me, I'm eating a sandwich. Ahh! I, I—just ran from work. I just gotta very boring phone survey job, and I ha—was starving. Yeah, I take what I can get these days. Uh, anyway hadda grab a sandwich, grab a cab—that cost me another six dollars!—to come here and bring you: THE SHOW. Aright? Which I've been bringing to you fur—a long time, fifteen—H-how long, Milo? Milo, my engineer, says it's been sixteen years. Bringing you live, uncensored radio, come rain or shine, under siege under fire, come Republicrat or Demican. If you haven't guessed aready, you're listening to WBAI, this is Jan Weissman and we'ron '*Tawk Yur Head Off.*' Aright, you know the number. 212–209–2900—Wur taking cwaulz about the Ebbets Projects case. Hello? This is '*Tawk Yur Head Off,*' you're oo-won the ay-er.

MELVA: Hi Jannie.

JAN: Hi. Is that you Melva?

MELVA: Yeah. (She breathes into the phone.) Ah, what kind of sandwich are you eating?

JAN: Well, I shouldn't admit this on the ay-er, I'm afraid Ah'll lose listeners, I'm not a vegetarian. Uh, I know its hypocrisy but I'm eating a pastrami on rye.

MELVA: (more breath) With mustard?

JAN: Of course. Are you calling abehh—about the Ebbets Projects case?

MELVA: Oh. What about it?

JAN: Uh, that's our topic for the day, Melva, how the police how the press are handling it, um—

MELVA: Well, in the first place. Uh the police are handling it very racistly, uh.

JAN: Oh of course I agree with you but how so?

MELVA: Well, the beating, it occurred, uh Easter Sunday, in East Flatbush, a neighborhood where there're People of Color, and they're referring to it as the Black Sunday case.

JAN: Yes, I made that point aready. What happened you weren't listening?

MELVA: No, I just tuned in.

JAN: Okay.

MELVA: Okay so, so uh, you made that point aready I take it?

JAN: Yeah.

MELVA: Oh, okay but further, uh, more I think the the press is just demonizing this gur-il. Uh, I, I mean won't say her name on the ay-er awlthough the *Post* has printed it, uh, because she's underage—

JAN: Yeah, she's thirteen—

MELVA: Yeah, she's only thirteen, uhh and of course whoops! the police somehow leaked her name. Uhhh! (voice goes up) which if

she were white, we know that wouldn't have happened.Uhh, if she were a white minor questioned for a crime she hadn't been arrested for or charged with, uh!

JAN: Oh yeah.

MELVA: Um, I also think she's being tried by the mob! Everyday there's a new revelation in the *Post* about this girl! Uh. She, she comes from a dysfunctional family in the Projects uh, uh she likes to take cabs, so where does she get the money for that! She must be dealing drugs—

JAN: No, actually the *Post* story was that she's using a livery service, (she takes a big bite of sandwich) they got a hold of the dispatch record that's how they know.

MELVA: Oh but no that's right, that was last week's article, but now she's been sighted in cabs.

JAN: Oh really? Where did you get this from? Was this the *Post* article also?

MELVA: Um no it was that racist radio station with those two assholes. Oh! I'm sorry Jan, I know you're having problems! And WBAI! And Pacifica! Uh those two beep holes, beep holes, uh uh, who are always insulting averybody they've been giving this case alot of coverage too.

JAN: Oh. Okay. And they don't think that the kid should have money to take cabs either? That bothers them too?

MELVA: Yes! It does. Uh I don't know what else tuh tuh add to it although I think there's a gender thing too because the sensationalism about this being a girl! It wasn't a gang of vicious boys that beat this, uh, poor old woman, no! It was a gang of vicious girls—prepubescent girls uh, supposedly, uh, beating this old Jewish woman on Easter Sunday!? I mean, it's oolmost, dare I say it—mythic? Uuuh uhh, and then I think the victim's name is Miriam! Isn't that from the Old Testament?

JAN: But okay! Getting back to the, to the suspect, the alleged suspect uh, y' don't think hur constitutional right of being innocent until proven guilty is really being afforded her?

MELVA: Absolutely not!! Moreover, I mean she's not being protected, she's a minor, she's undera—

JAN: I agree with you, Melva. Okay we're gonna hafta move on. I agree. Um unless there's something else that you'd like to add?

MELVA: (Quietly) No that's it.

JAN: Thanks alot, Melva.

MELVA: Enjoy your sandwich.

JAN: Thank you I am. Okay, '*Tawk Yur Head Off,*' you're on the air.

Miriam's Dinner Party

Los Angeles, 1950

MIRIAM:

July 12, 1950

Dear Ester,

How can I begin to describe our calamitous dinner? I've told you about Chad and Ruth Davies. She's annoyingly self-righteous; he's a good enough sort, a committed reformer, and then there was Carl Pruitt, the artist draftsman who helps the children in the Spanish barrio, and a fellow he brought along, a social scientist by the name of Leonard Vartson—he's lived in Mexico and written a few books—one on the revolution and another simply called *The Mexican.* Lonnie was predisposed to dislike all of these people from the outset. I should've known when he got hot under the collar discussing Trotsky with Carl while we were still on triscuits, cheddar balls and cocktails. Lonnie's been drinking rather heavily—he goes out quite alot with new drinking

friends. His usual screenwriter's funk has been compounded, I think, by his recent troubles with the anti-communists at the Studio.

So there we were, barbecuing out on the deck. (The only pleasant part of the house as far as I'm concerned. The rest is all modern angles!) There we were, and I rather innocently began talking about the Spanish ghetto, in particular, La Lomer, where my child-friend Gabriela lives. Lonnie finds my friendship with this girl suspect—basically he believes any 'ameliorative measures'—in other words, helping people get along—keep the Mexicans in their place instead of inciting them to strike or riot which is what he wants. He may be right but my interest in Gabriela is more selfish than that. She's simply a child who compels. She reminds me of you Ester, with her dark skin and eyes and her imagination that startles and breathes life. At times I feel as if I can't get through another relentless hot day here in the Southern California fry-pan without a visit to little Gabriela, writing down another of her tall tales.

(She changes the subject.)

So, I made a salad! (The produce here is so fine!) Chad Davies told us of his new job with the Housing authority, how they've now plans to buy up all the land there in the Mexican barrios and build a public housing works. Carl Pruitt has helped draw up the architectural plans and he thought that the Mexicans would benefit from a housing projects. He said the structure might finally introduce them to the amenities of indoor plumbing and good floors. I had to voice an objection. Although the poverty in the barrios can be shocking, somehow I couldn't see the Mexicans being comfortable in apartment complexes with modernist architecture. Carl Pruitt and Lonnie love this house we rent, but I don't think the Mexicans would.

'Ha!' Lonnie said, 'you see, for once, here is an idea to open the public coffers and improve their lives, and you'd rather they go on

subsisting in their quaint poverty.' I could tell Ruth Davies was pleased to see Lonnie attacking me in this way. Her dull eyes lit up.

To my surprise, the social scientist fellow, Leonard, weighed in on my side but his weighing in was what sunk the ship. He began to tell of his experiences in Mexico, and said that like it or not 'the Mexican' is a fatalistic reactionary soul. Though the housing projects might indeed benefit them, he predicted, the Mexicans would not be happy there, would reject a modern civic life. Somehow his agreeing with me was worse than siding with the others. I kept trying to articulate the difference, but my protestations that sagging porches overgrown with roses are pretty were met with disbelief and incomprehension by all. Mr. Vartson kept sweeping aside my argument and saying, 'She's in the infatuation phase, I know it. I was too when first I set foot in Mexico but that passes, she'll be disenchanted. The real argument against this project is that it will not work.'

Papi Y Mendoza

Los Angeles, 1951
Mr. Mendoza and Papa Zorrita sit outside Mendoza's store at dusk.

MENDOZA: Flowers, flowers, *flores:* that's the first thing I saw when we got here to California.

ZORRITA: Oh, you always talk romantically about this place because you like to see life that way. Your family didn't fight for the *revolución.* You ran here and started a store.

MENDOZA: We fought. We just fought against your side. Pancho was a bad man.

ZORRITA: I should cut out your tongue, Mendoza.

MENDOZA: *Cabron*, then you'd have no one to argue with. Your Pancho Villa did things like that. I had a cousin, *una belleza*, a beautiful cousin. He fell in love with her and when she refused him, he cut off the, the tips of the noses of her family and left them in a bowl on her kitchen table.

ZORRITA: He did not.

MENDOZA: He did. He never let her marry. He killed both of her fiancés—hung one and shot the other. After that, no one, not even a *gringo*, would marry her although she was beautiful. Why would I side with a man like that?

ZORRITA: The landowners did worse to *el pueblo* of *Mehico* for centuries. It was commonplace. And besides, these are just stories spread about Pancho to discredit him.

MENDOZA: No, this was my cousin Beatriz, *una belleza*.

ZORRITA: No, I don't believe you. You still have the tip of your nose.

MENDOZA: Well, it was only her immediate family. I was her cousin.

ZORRITA: So you see, Panch spared you, he was kind *y justo*—just!

MENDOZA: So now you say you believe me? He cut off the noses of my *Tia* and *Tio* and my seven cousins!

ZORRITA: I don't want to talk about it you are hogging the tequila pass it to me.

MENDOZA: Okay. (He doesn't pass it.) But let me say that *Mehico* was a dry place of too much fighting. I had to flee with my brother. We walked. We carried everything on our back. I like it here. We came here and there were flowers everywhere.

ZORRITA: You never fight. You let them take your store away and tear apart our *barrio* here to build their *pendejo* housing projects.

MENDOZA: It's sad. Yes, I agree, but what can we do? I went to City Hall to reason with them.

ZORRITA: They won't listen to you. Here, you are nothing; never mind that in *Mehico* you are a son of an *hidalgo*.

MENDOZA: I still say here is better. I can change professions here. I think I'll become a door-to-door salesman. We'll move to Pasadena.

ZORRITA: Won't you miss it?

MENDOZA: I won't miss you, I can tell you that. Insulting me every day of my life and forcing me to share my best tequila.

ZORRITA: You *don't* share it!

MENDOZA: Here here take it.

ZORRITA: That's *bet*ter.

WBAI

New York City, 2001
Jan gets a new caller.

MAURICE: George W. Bush, uh. George W. Bush is in the, uh, is—is currently in the process of one by one liquidating each and every person in America who in anyway shape or form—

JAN: Uh, Maurice?

MAURICE: —George W. Bush is liquidating every dissident voice in America—

JAN: Ah, Maurice? We're not talking about that. We're talking about the Ebbets Projects Case. Do you have anything to say about that??

MAURICE: Yes, I do.

JAN: Okay, what is it?

MAURICE: Uh, uh it is that George W. Bush is using that case and a myriad of other distractions uh, uh to—to undermine the already

rancid, deluded, decaying, corrupt left wing, the rancid idiots who call themselves members of the—the radical uh uh uh uh—

JAN: Okay Maurice goodbye!

MAURICE: You are one of them Jan!

JAN: Okay. Thank you very much, Maurice. We're—We're saying goodbye now. Have a nice day.

MAURICE: You are censoring me, Jan!!

JAN: Yes I am. Bye. (dial tone)

Hannah Meets the Rabbi

Brooklyn, 2001

The dial tone transitions to the squawks and farts of dial-up as Hannah's computer goes on-line.

HANNAH:

> TO: Klugdude@globix.com
> FROM: HaHaHannah@xerxes.net
> SUBJECT: Rabbi at Starbucks

Dear Josh,

You're not going to believe what just happened. I see it as divine intercession, but I'm sure you'll dismiss it as coincidence. Last night after I wrote you about Aunt Mir, I fell into a cold sleep around three a.m. I slept only a few hours and I crawled out of bed and walked to Starbucks on 7th Ave. You know how I said I was going to get my triple *grande latte* and go find a Rabbi? Well Josh, that e-mail got sent to the ear of some unnamable divine presence, because I'm sitting there with my coffee, trying to remember where that reform synagogue on Prospect Park is, actually, when out of the corner of my eye, I see this man in a beard and a hat

rocking just a little. I turn and it's a rabbi, and he's doing a little prayer over his coffee and zucchini muffin.

He looks up at me and I don't even have to introduce myself, I just go over there, and all he says is, 'You are Jewish. I'm Rabbi Dave Dovkind, sit down. What is that? A triple *grande latte*?' I say, 'Yeah, you guessed it.' And he goes, 'You keep kosher?' I go, 'Not really, is it kosher here at Starbucks?'

And he goes, 'Yes, Starbucks is kosher. They do it very well here. This is all kosher.'

I knew this wasn't true, but somehow it was bizarrely reassuring, like Josh, remember when were kids and we'd visit Aunt Miriam in Brownsville and we used to tell her dad says that Brooklyn is going to hell and we should all move to Long Island and Auntie Mir would go, 'No, no, everything is fine. Brooklyn is having a cultural renaissance. It's never been better.' Just when you know it isn't true but you have this very certain person telling you it's fine it's fine, everything here is changed all the standards you use to measure are shifted underneath you but it's still the same, it's still good. It's kosher. Starbucks is kosher and you're a good girl, you always have been. Sit down.

It turned out Dave Dovkind was a pot-smoking orthodox Hassidim, you would've liked him, Josh, you would've. He would've been like, 'So you're an atheist, that's fine, that's fine. What kind of coffee is that? A *mocha frappe*?' I swear. He was awesome.

So I spilled my guts about Aunt Mir being torn to shreds by bastard children at the Ebbets Housing Projects and he just started reminiscing about going to ball games at Ebbets Field when he was a kid. He had this blissful smile on his face, telling me about his two friends Joe and Nathan and how he met them fighting to defend Mickey Mantle because he was a Yankees fan. Somehow, it was bizarrely reassuring.

Bumstew

Los Angeles, 1954

Portnoy and Wentworth sit sharing whiskey.

WENTWORTH: Now wasn't that savory? You see, when we pool our resources—Perhaps Mr. Dreyfus will have some. Mr. Dreyfus, come down! Come down and sup with us!

PORTNOY: He's lookin' at the Spanyos. The tractors. Lookit it go.

WENTWORTH: Yes, they are making great progress in removal of our neighbors' homes.

PORTNOY: Nah, why cain't they tear down Dreyfus's creation of shit while they're at it?

WENTWORTH: Well friend, I'm sure the forces of progress will get to that one of these days. But bear in mind, you shall go down with it.

PORTNOY: Well. Hmmph. And you, Wentworth? What'll you do? Undig your tincan of hundred-dollar bills and go your way? Maybe put up in a hotel downtown?

WENTWORTH: I have no tin can of hundred-dollar bills, Portnoy.

PORTNOY: The hell you don't, I'm no fool—

WENTWORTH: You aren't.

PORTNOY: That's right and I've pieced together your life story from all the used to bes you let slip when we're sharing whiskey and let me tell you with all the railroads and irrigation dams and citified plans you had a hand in, I wouldn't be surprised if you didn't OWN one of them hotels down there on Wilshire Boulevard.

WENTWORTH: Portnoy, your capacity to dip into the great one mentality can be astounding. Eerie.

PORTNOY: Speak plain English!

WENTWORTH: (flabbergasted) I'll concede you are correct; at one time I owned such an establishment on Wilshire Boulevard.

PORTNOY: There! You see.

WENTWORTH: But now friend, I tell you, once and for all, I washed my hands of buildings and structures other than our ramshackle ridge. I buried my money, it is true, but not in a place where it could be 'undug.'

PORTNOY: Why, if it's buried in HELL, I'll go and undig it. You need only tell me where it is you philosophizin' thief.

WENTWORTH: I gave it to an Indian tribe.

PORTNOY: Liar.

WENTWORTH: I did.

PORTNOY: What was your confounded reasonin' in that regard?

WENTWORTH: I don't wish to tell you.

PORTNOY: Have some more whiskey. I'll piece it out of you yet.

Miriam's Dinner Party

Los Angeles, 1950

MIRIAM: At first I was surprised Lonnie supported the new housing plan and did not find it 'ameliorative.' Then, naturally, he got incensed with Carl and Chad on just those grounds saying that he supported it for entirely different reasons. Not as a New Dealish measure but as something that would eradicate their traditions and thus, their colonial serf-mentality and drive them to a truly modern revolutionary capability. I started screaming at him, 'How'd you like it if that happened to Brooklyn? No more corner shop? No more egg creams and knishes?' He hollered back he wanted that to happen to Brooklyn. He hated all the nationalist ethnic rivalries, the claustrophobic traditions. He said that's what he liked about California—NO CULTURE WHATSOEVER. I said there is, you simply refuse to see it. You prefer your ideology.

Needless to say, the dinner party was a shambles. No one could really agree on anything apart from the fact that all of our disagreements might soon be rendered immaterial if Mr. McCarthy were to have his way. Everyone kept hollering at me 'Well, what do you want? Things to stay the same?' And all I could secretly reply was, '*Yes! Yes!*'

Hannah Meets the Rabbi

Brooklyn, 2001

Hannah's e-mail continues.

HANNAH: Rabbi Dave never addressed my rage, my horror, my racist anger at Mir's attackers. He just sat there reminiscing. He told me about the subway series back in fifty-something—everyone in New York was excited. This one game everybody played hooky from school. The doctors' offices closed. If you needed to go to the dentist, you had to wait. Everybody in the whole five boroughs was either at the game or listening, or waiting for it to be over so that they could go back to their business because everything was frozen. I said it sounded like when we have the blizzards and no taxis can get anywhere and no one can get anything done in New York and people ride sleds down the streets and he said yes it was very much like that, everything just stops and we just listen to the pulse.

We talked for about an hour and then he just left. He never even said I'm sorry your aunt was attacked. All he said was, 'Nice to meet you Hannah. You were very well brought up. I'm sure you know that.' And he left. I almost felt like I hallucinated the whole thing. But he gave me his card. He has a website, which I thought you'd

find irresistible. It's www.l'hem.org. It means bread in Hebrew, Josh, in case you forgot. Bread dot org.

I went to Aunt Mir's apartment and got that suitcase of letters that she wrote to Mom and I rode the bus to the hospital and sat there and read all these memories aloud to Mir. She lays quiet, but some part of her hears. I feel bizarrely serene now. Maybe just because this crisis means that I don't have to go and look for temp-jobs.

I got your phone message. Keep trying.

Love, Hannah

SEND!

WBAI

New York City, 2001

JAN: (exasperated sigh) Haah! Hello! This is '*Tawk Yur Head Off.*' You're on the ay-er. Are you calling about the Ebbets Projects case?

ROLANDA: (African-American) Hi Jan, this is Rolanda speaking.

JAN: (at this point she's picking her teeth with a toothpick. She perks up hearing Rolanda.) Oh. Hi Rolanda. What d'you think about the way the press and the police are handling this case?

ROLANDA: Wey-ell, of course they're handling in the usual racist and sloppy style to which we've all grown accustomed uh but uh that isn't the issue that I wanted to address. Uh, there's something else that this case, uh touches off inside of me that I'd like to discuss.

JAN: Okay, Rolanda! I always like what you have to say. Go ahead. Shoot.

ROLANDA: Alright. Well, now, in all the material, uh, that I've read about, uh, Angela.

JAN: Uh, th-the underage suspect?

ROLANDA: Yes, *Angela*.

JAN: Um, Okay, Rolanda, we prefer not to say her name on the ay-er beause we feel that is—

ROLANDA: But let's get real, alright? She's been on NEW YORK ONE, everybody kno—

JAN: Aright, Rolanda let's just not—uhp! I accept that you have a different point of view on this okay. Why don't we just continue so that you can make the real point that you wanta make.

ROLANDA: Okay-ee. With all the material that I have seen and heard about *Angela*, uh, I see that she is a gifted child. Uh, she has the profile. Uh, she's uh exceptionally fragile, uh, exceptionally alert. Um, I think she is, uh, most certainly reviled and misunderstood. Uh, I think she may have a slight bipolar problem.

JAN: Yeah, I know what you mean. Oh yeah, I thought that too.

ROLANDA: Okay but, ah, the point I'm trying to make is that with*in* her own community, I think Angela may be a person who has been in the past criticized, disapproved of, disliked because from birth she has been a very gifted, strange African-American girl-child.

JAN: Okay. But—

ROLANDA: Her father and her brothers are in prison, uh, her mother has some form of narcolepsy. And yet, she's in*cred*ibly poised. She exerts a magnetism, uh, over her—her peers, over girls her own age. Now I think some people in her community might look at that and say: Why? What is it about her? Oh let's see: I think Angela did it. You know what? It must be Angela. Because she is so distinct. And people don't approve of this.

JAN: Wow! Okay, Rolanda. Thank you very much. A new point of view. Interesting.

ROLANDA: Well. Thank you for letting me express myself, Jan.

JAN: You're welcome. Okay this is '*Tawk Yur Head Off.*' You're on the air.

Viviana's Going Away Party

Los Angeles, 1953

The three friends are up on the top of the hill, looking out.

CAROLINDA: *Mira*, Lucky and Hermansillo give me this red wine for Viviana's going away party.

GABRIELA: Some party. There's only the three of us.

CAROLINDA: (She sits down.) Look at Mendoza's store burn.

VIVIANA: I don't understand. How come the firemen have to practice putting out fires anyways?

CAROLINDA: So they can learn how to put out real fires, *tonta*. Like you, Viv, practicing French kissing on that wine bottle so you can kiss your Juanito Bambino goodbye. Look, she practically swallows it! She got her lipstick all over it! Guh!

GABRIELA: Let me try some. Yuk! Why are we drinking this anyways?

CAROLINDA: For Viviana's going away party!! Hooray!

GABRIELA: I don't like wine.

CAROLINDA: Oh Gabriela, such a good girl now, since you get your story published by that white lady in the newspaper. What did it say? 'Lit-er-ary Ta-lent Blossoms in Rough Terrain of Chavez Ravine?' What the heck does that mean? Huh!

GABRIELA: Mrs. Miriam didn't put me in the newspaper. I only won second place in the city contest. Mrs. Miriam told our school about that contest, that's all. She says it's good for people outside to read about us. Then maybe they won't think we are a slum.

CAROLINDA: Rough terrain. Isn't that just a fancy way to call us a slum? But four eyes is the blossom from the slum, not like us weeds! Four-eyes gets good gra-ades! Four-eyes is a tea-cher's pet!

VIVIANA: I *like* your stories, Gabri. That one they put in the paper was *muy linda*. About your grandmother and her herb shed how she takes you all over the hills to gather her *yerbas* and she tells about *Mehico*. Didn't you like it, Caro?

CAROLINDA: Sure, sure, I liked it. You two want to try to smoke a cigarette? Lucky and Hermansillo gave me a cigarette.

VIVIANA: Oh, Caro you such a *delinquente*. My mami says if Caro is this bad at thirteen, wait until she's sixteen. No decent boy will go with her.

CAROLINDA: (She puts the cigarette in her mouth, but doesn't light it. It wobbles around as she talks.) You mami is a rabbit. Instead of Castellanos your family name should be *Conejos*—rabbits—because you all act scared all the time. Like your Papi—now the housing projects is off and those commie men in their bad suits don't come around no more, he still has to make you all pack up and *vamanos, como* scared rabbits. *Estupido.* 'It's no good to make trouble. We sold it to the city already. No trouble no trouble no trouble.' He's like a rabbit, your Papi.

VIVIANA: My Papa hurt his back. It hurts him to work in the fields. He hurts *todo el tiempo*... Besides he can't read no English.

GABRIELA: Yeah. Look at it from Vivi's eyes, Caro.

CAROLINDA: I don't want to. I got my own eyes. Maybe now you got those glasses that white lady Mrs. Miriam bought you, Four-eyes, you see things from too many eyes. Pass the wine. You're just spitting it out in the grass anyways. I'm going to get drunk.

VIVIANA: Ay, she's going to get drunk and vomit. My mami says it's good we're moving, Caro because you're a bad influence—*una delinquente*.

CAROLINDA: Huh! You the one sliding your skinny *culo* to second base with Juanito Bambino and lying about coming up here all the time to Jerry's Liquors. I don't lie.

VIVIANA: *Pero* you hang around with Lucky and Hermansillo. Those twins are *malo*. They act angry all the time.

CAROLINDA: That's why I like them.

GABRIELA: Why?

CAROLINDA: They're like me, they're *mis hermanos*.

GABRIELA: Squint up your eyes.

VIVIANA: *Porqué?*

GABRIELA: *Porqué* this is the last time we're all going to see this view.

VIVIANA: No, I'll come back to visit.

CAROLINDA: But it won't be the same. (she gargles wine and swallows.)

VIVIANA: Sure it will. We are friends forever—Vivi, Caro, Gabria, *verdad*?

GABRIELA: *Si*, for sure. But the view, the picture won't be the same.

CAROLINDA: Look at Mendoza's store burn. Hey, I got an idea! Let's go throw rocks at the fire truck!

GABRIELA: I used to sell Don Mendoza extra milk from Fonda the goat, and he would give me flour.

CAROLINDA: Write a story about Mendoza's. 'Member how all our Papi's stood around there for hours and hours?

GABRIELA: I don't know.

VIVIANA: Why not? You could write a story about *qualquier cosa* Gabria, it don't matter what. You always make it good.

GABRIELA: No. Because—*Yo no se, pero*—Mendoza's is gone, *pienso que no*...

VIVIANA: Ooo! The wall just fell! Look at all those sparks! I wonder if firemen are good kissers.

CAROLINDA: Go find out, slutita.

VIVIANA: Shut up, *delinquente.*

CAROLINDA: You shut up!

GABRIELA: Stop fighting. This is Viviana's last night! Caro, if you going to drink that stupid wine, then make a toast for Vivi.

CAROLINDA: Okay. Adios, Viviana! Adios, Mendoza's store!

GABRIELA: Come on, let's hold hands. *Amigas para siempre?*

CAROLINDA: (groaning) *Sí!* Yes!

VIVIANA: With her? I guess, yes. Friends forever.

GABRIELA: Okay, now squint up our eyes.

CAROLINDA: I am.

VIVIANA: Me too.

GABRIELA: Adios, View.

CAROLINDA AND VIVIANA: (They shout.) ADIOS!

GABRIELA: (Quietly) Adios.

WBAI

New York City, 2001

DAVE: Did you ever go Jan? See the games there? See the Dodgers play?

JAN: I hate to tell you, Dave, but I never gave a beep about baseball—or any sports for that matter. Do you want to talk about the Ebbets Projects case?

DAVE: Wasn't I?

JAN: No. We're going to have to move on.

DAVE: Oh, o-okay okay. Bye Jan...

Bumstew

Los Angeles, 1954

Portnoy and Wentworth are drunk.

WENTWORTH: My parents ran a mission school for Indian children.

PORTNOY: There. Y'see, you yourself had a overly religious upbran-hic!-ing-hic!

WENTWORTH: Eh, they were East Coast people, my parents, and they believed that the Indian ought not be exterminated. They believed he was educable. Could be taught to be a white man.

PORTNOY: What manner of man was your father?

WENTWORTH: My father was a harsh taskmaster.

PORTNOY: Mines was merely a regular mean ole sonofagun.

WENTWORTH: My mother wore collars up to her ears.

PORTNOY: Tee heee heeheeee heee heee!

WENTWORTH: I myself wore dresses 'til age nine that was the fashion then.

PORTNOY: You played in a petticoat?

WENTWORTH: I had no one to play with. I was not allowed to play with the Indian school children. Apaches mostly. So then I began reading.

PORTNOY: That's when you storted in own yer damn philosophies.

WENTWORTH: No no no no! I read about the CAPTAINS OF INDUSTRY. That's what I wanted to be, you see, an industrialist. I had a little train set my uncle sent: choo choo choooo! Ha ha ha.

I was sent East for my later schooling I—became smitten with civic ideas I had an idea of a grand planned utopia an industrial society with all the civic eh—er the civic ehhh?

PORTNOY: With all the civic trimmin's?

WENTWORTH: YES! Exactly! All the civic trimmings. So I took the train to California and I started my Plan. I even wrote a poem on the way there 'Oh California, you golden state, land of straw hillsides and silver creeks, land of irrigation and windmills...'

PORTNOY: And what else?

WENTWORTH: I forget. It wasn't very good

PORTNOY: No, it wadn't. And then?

WENTWORTH: Oh, the rest is too tiresome to go on about. Most crucially I came here, to my hillside. My unplanned king-dom of ramshackle, my savory bumstew, m—

PORTNOY: Ah quit, now tell me why did you not stop in on your parents on the way west agin?

WENTWORTH: Did I say that?

PORTNOY: No, but I knowed it. Now tell me now while you're able.

WENTWORTH: (He is once again flabbergasted by Portnoy's powers of intuition.) What? Astounding!

PORTNOY: Did you visit them?

WENTWORTH: No, I didn't.

PORTNOY: Tell it! I say tell it!

WENTWORTH: There was a young Indian fellow, my mother's favorite, almost a son to her. His Christian name was Lucian. He was four years my junior and I was fond of him as well. Well, Lucian had become an exemplary white man. He spoke English like a Harvard man, he wrote essays and poems, and he sang beautifully. He was to study economics at a Negro college. But then he fell in love with a young white girl. And she fell in love with him, but there was no chance of them marrying. He became despondent. He ran off to his tribe. He returned shortly. His hair had grown out but nothing more. After a few days he hung him-self in his bedroom. His note blamed my mother. He said by

hanging himself, he was simply finishing the work begun by my parents when he was three years old. My mother wrote me of this tragedy. I never replied. I never communicated again with either of them. (He wipes away tears with his beard.)

(Long silence.)

PORTNOY: Ahem! That puts me in mind, I never did tell y'all about my movie today.

(The other hobos chime in.)

OTHERS: Oh no, that's right. Ah, yeah, y' movie? Oh, ya didn't tell us.

PORTNOY: It was a cowboys and Indians picture.

WENTWORTH: Oh?

PORTNOY: That's right. *Yippe ci yi yay.* Pass along that whiskey, Brinks. Let's hand old Sam Wentworth here a sip. Ahem! *Yippee cay yi yay, yippie cay yi yay!* They had me sayin' that all the live-long day.

(The other hobos laugh at Portnoy's drollery.)

PORTNOY: (He makes high lonesome mournful yips.) *Yippee,* I say, *a yippee* I say, *a yippee cay yi yay-i-eeee. Yipeee,* I say, *a yippee,* I say *a yippie cay yi yay-yuuuh.*

As the other hobos laugh and grunt, Wentworth and Portnoy exchange a glance of mutual understanding. The sun goes down.

Colina De Los Sueños :

Dream Hill

Angela's Cab Ride

Brooklyn, 2001

A cab pulls over on Seventh Avenue, in Park Slope.

ANGELA: (gets in cab; she speaks incredibly rapidly, deadpan and manic at once) Yeah, just drive me down to MckeeverBedford something I get out there.

MIKE: Hey, it's you again.

ANGELA: Who?

MIKE: It's you. You don't recognize me? I picked you up two other times. Remember?

Middle of the night. Dropped you off right here at this hospital. You don't remember?

ANGELA: Naw—Yes—Naw, I 'member, Hmm.

MIKE: We had two separate conversations. Well, *I* did. You don't talk too much.

(Silence. Angela looks around, out the window, evasive, in her own reality.)

MIKE: Do you?

(More silence.)

MIKE: Right. But you remember last time you asked me about a perfect game?

ANGELA: What?

MIKE: Yeah I'se telling you about all the different style pitches all the pitchers and you asked me when you got out the cab what's a perfect game?

ANGELA: Oh yeh I remember make sure the other si' can't even score shit.

MIKE: We-ell that wasn't exactly how I put it but that about sums it up.

ANGELA: That sums it up, yeh.

MIKE: Mckeever and Bedford. That's by Ebbets. Last time I picked you up you were standing right outside that Ebbets Projects where you live. You live there right?

ANGELA: I don't say I do an' I don't say I don't, if you won't give me two, gimmee back the one dollar that I loant.

MIKE: What?

ANGELA: Yeh. Yes. Hmm.

MIKE: You're a weird kid. My names Mike, kid, what's your name?

ANGELA: You don't-read-the-papers-watch-TV?

MIKE: Whadda you, famous?

ANGELA: Yeh!

MIKE: Heh! No. Y'know dat's funny you should ask. Uh well, y'know, but I don't read the papers or watch the news. I quit all dat since my divorce. I was—I was gettin' stomach ulcers. I cut out drinkin' coffee, cut out alot of things. Now I just talk to people that's what I do drive around have conversation. I listen to the oldies stations or jazz. Soothes my nerve. No news. I just switch it off. I feel much better. It's good.

ANGELA: Dat's good.

MIKE: Yeh you should try it some time. Well, y' know, you're young you probably don't even care about the news.

ANGELA: Jimmy crack corn an' I don't care.

MIKE: What?

ANGELA: Nothing. I's a song I heard.

MIKE: So what's your name, kid?

ANGELA: AN-GE-LA DE-MAYO. (expectantly)

MIKE: (no reaction) Uh-huh.

ANGELA: Uh-huh.

MIKE: So listen, y'know, what're you doin'? You're a little kid to be running around takin' cabs in the middle of the night, what are you doin' goin' back an forth between Ebbets and the hospital so late at night, huh? It's not your typical visiting hours.

ANGELA: Not your typical, no. (changes subject, looks around) Oh! You changed your cab.

MIKE: What? Oh yeah, yeah. I started fixin' it up in honor uh the Dodgers. Dat all started since I had dat first convehsation wit you. I dunno why. You brought dat whole story outta me, maybe cuz I knew you weren't listening, you know? Like a priest? Anyway, ah, maybe I had the Dodgers on my mind t'begin with cuz, uh, I remember that night distinctly. I dropped off a fare over by Windsor Terrace, I said, Hey, I'm near da old naybahood, why don't I go? I neveh did dat befoah, but, you know (he sings) 'Destin-y.' So I drive oveh deh and there you are over standin' on Montgomerey where left field used to be—dis skinny little kid— excuse me but you ARE a skinny little kid—wavin' me down. And, y'know you got in the cab and I told you dat whole story about the time me and my pals went to uh, to see the Dodgers play in Phillie after dey became the LA Dodgers? And, uh, y'know, it just wasn't the same, uh…

ANGELA: Oh yih! Now I remember. You went and you said it was like when your wife divorce you and you seen her again.

MIKE: Yeh! Deh you go. So anyway afta dat I found myself comin' back here accasionally when I get a Brooklyn fare, t'inkin' about the Dodgers again, y'know. And I started dec'ratin' da cab up.

ANGELA: I like it. It's sick. I like it.

MIKE: Thank you, you like the blue satin?

ANGELA: Sure, yeah you got some old school ball players up here, right?

MIKE: Yeah, I got Pee Wee Reese, Roy Campanella, uh-

ANGELA: Who's the black son with the coffee cup?

MIKE: Oh yeah, dat's Jackie Robinson. That's my Jackie-doll. I made dat personally—

ANGELA: What's he drinkin'?

MIKE: Aw, he's drinking Chock Fulla Nuts coffee. You could say, well you could say it was the Stahbucks of its day. See. The owners tried to trade Jackie to the Giants right before dey moved the team away and Jackie just couldn't take it, he refused, after takin' all that abuse for them he wasn't about to go and play ball for the Dodgers arch-rival. That just added insult t'injury. So he retired and he took a job workin' for Chock Fulla Nuts. That's my own little—I made that Jackie-doll. Y'like it?

ANGELA: Yih, yih! I like dat little bat light too.

MIKE: Yeah, well now that's modeled afta, y' know, a chandelier dey useta have over at Ebbets Field. Dey had a huge light dat had uh twelve bats for arms and globes det were shaped like baseballs.

ANGELA: That's sick.

MIKE: Yeh yeah, it was. Sick. Yeah, thanks. Well y'know I figured I own this cab, I worked my tail off for this medallion, why not make the space nice. I been readin' up on this Chinese system dey got call feng chewy dat says—

ANGELA: Oh yih, I heard of that!

MIKE: You did?

ANGELA: Oh yih, My cousin Shauna she's into that. She did half of Ebbets with with those little mirrors an' wind-chimes.

MIKE: No shit.

ANGELA: Oh yeah. Fong shoe she calls it: Take back your space! Lib your crib! Empower your shower! Like dat.

MIKE: Dere you go! How 'bout that? Hey yy-yyy-y you seem like a good kid. What're you doin' runnin' around late like dis, huh? You mother know?

ANGELA: She sleeping.

MIKE: You sneak out.

ANGELA: No, I don't have to because she goes out like toast in a toaster she go blank. I do too. I go blank and I forget things.

MIKE: Oh yeah? You see a doctor about dat?

ANGELA: Dey don't know. They give me Ritalin but I threw it out.

MIKE: You're better off. Doctors don't know shit. Yur a smart little kid.

ANGELA: Yeah, I see things when I'm blanked out.

MIKE: Humm. You're eitha psycho or psychic. Maybe yur psychic. Like Mrs. Cleo. You know Mrs. Cleo on TV? Dat infomercial? She's got the, uh turban—

ANGELA: Yih! I like her, she's sick.

MIKE: Yeah, I called her once and she was very helpful. She said Mikey darlin' you're a good mon, darlin'. Just keep on wit da keepin' on and tings will work out for ya, darlin'. I like her, the way she talks. I like the island people they got that bouncy way of talking.

ANGELA: I hate those people.

MIKE: Oh yeah? Lotta people round here like dat.

ANGELA: I know. I hate them. I hate dose people.

MIKE: Yeah? I know a couple cabbies from Jamaica. Dey told me try the all night goat stew place around here. So I went, I never had that before. Never ate goat. Not bad.

ANGELA: Euh! I hate their food. Hate those people.

MIKE: Yeah, well, some things never change. That's just like the old days. You know the Italians hated the Irish. We hated them back. We all picked on the Jews. Then along came the Puerto *Ri*cans

ANGELA: I'm Puerto Rican.

MIKE: Y-You look black.

ANGELA: I'm half-and-half.

MIKE: Yeh. Wull… but, we all play one big ball game, you know? Baseball is like an analogy for the whole nine yards of life. You know what an analogy is?

ANGELA: No.

MIKE: It's like baseball equals life, get it?

ANGELA: Nuh, I never gave a shit about baseball or any sports.

MIKE: Ah, Okay—how do you feel about life?

ANGELA: Don't give a shit.

MIKE: Dere you go! You see—

ANGELA: You could drop me here.

MIKE: Okay.

ANGELA: Here. (pays him)

MIKE: Yeah. Hey, Angie. Tell me what you're up to kid. What're you doin' at that hospital?

ANGELA: Youreallywanttoknow? (Rapid-fire)

MIKE: Yeah.

ANGELA: I go visit a old lady.

MIKE: At this ow-uh?

ANGELA: At this ow-uh.

MIKE: Is she awake?

ANGELA: No she asleep. She blanked out too. But she sings.

MIKE: She sings?

ANGELA: Yeah she sings and I hum.

MIKE: How come you don't go durin' the day?

ANGELA: Cause she only sings at night. Keep the change. Bye Mr. Mike.

MIKE: Hey kid—(He looks but she's disappeared.) Hmm, weird kid. Weird little kid. Can't get a straight ansuh. Tree times. Tree times. Strange. Hmm. (He drives off.)

NY Core-US

Brooklyn, 2001

F train doors open, the subway sighs and discharges.

CONDUCTOR: Coney Island, Stillwell Avenue, last stop.

CHILD: *Mami, mami* look all the rides ah open—all the rides look! All the rides ah open.

 (The waves pull in and out, a little boy screams and giggles in the capsizing waves, seagulls cry.)

MOTHER: (softly) Miguel, *vamanos*, Miguel!

 (A vendor carrying an ice-chest walks the beach.)

VENDOR #1: (robust) *Agua*! Sodas! Cor-ro—nas!

 (Time passes. The Wonder Wheel turns, the passengers on the Cyclone Roller Coaster squeal. The little boy keeps playing in the surf. Seagulls coast the air currents, circling and crying.)

MOTHER: (still softly)) Miguel, *vamanos*, Miguel!

 (The little boy laughs. A second vendor passes by.)

VENDOR #2: (Tired, flat) *Agua*! Sodas! Cor-ro—nas!

(More time passes. The little boy jumps in the foam. His mother calls again, a little less softly.)

MOTHER: Miguel, *vamanos*, Miguel! *Ya te lo dije.*

(A third vendor passes by.)

VENDOR #3: (meek and sad) *Agua*! Sodas! Cor-ro—nas!

Gabri Flies

Los Angeles, 2001/1958

GHOST GABRIELA: One thing surprises me about being dead, God, and that is, I never thought I would die so young. *Mi bis-abuela* lived to be a hundred, *mi abuela* was ninety. Why'd you have me go dropping dead of a heart attack at sixty-one? Maybe you want to teach my *pendejo* grandson something hmm? Spinning his records over my dead body and me flying around the old neighborhood like Samantha *la Embrujada* trying to figure it out, huh? Is this like staying after school, can't get to heaven 'til I do my homework? I already asked you that. (Hums "Bewitched" theme song.) Ay! I could really use a Coke or a Sprite, let me tell you.

Here we go: Ah, okay, Elysian Heights. Looks like the 50s, people barbecuing, fixing their cars, dogs barking their heads off. It's still pretty much the same, only back then there are way more kids and way fewer trees. Mrs. Miriam on Hummingbird Terrace. They called it Red Hill because people said the people there were communist. We're in her backyard. I'm reading to her...

Last Wedding in La Loma

Los Angeles, 1957

TEENAGE GABRIELA: 'The last wedding in La Loma before they tear it down.' It's three a.m. in the morning and the wedding is still going on. My *Papi* is in the street drinking tequila with our neighbor Señor Mendoza and arguing about the Revolution. *Papi* is for Zapata. Mr. Mendoza is *contra*. They threaten to kill each other, then they dance. No one seems to have any idea of going to bed.

MIRIAM: Any intention of going to bed? Isn't that what you mean?

TEENAGE GABRIELA: No, I mean idea.

MIRIAM: Alright, go on.

TEENAGE GABRIELA: We have a whole bunch of people playing music by the water tower: guitars and accordions and the *vatos* drumming on anything they got—peach crates, orange crates, tomato cans. Boys and girls off in the corners kissing; the old women in the other corners staring at them. The children and everyone else is dancing or just walking around on the moonlit streets. It's a big wedding party that won't stop. Most of our people have moved away but alot of them came back for Nina and Victor's wedding. Vico is his nickname. Nina doesn't have one. She's well mannered well brought-up and fat. Real pretty round face. *Una gordita linda.* In English: A chubby beauty?

So normally this wedding should have quieted down when Vico and Nina drove off to visit Vico's relatives in Arizona but this time, since so many people have moved out from La Loma and are back just for the occasion it seems like they don't want to go and we don't want them to neither. Even though there's been *mucha amargura* about people selling or not selling.

MIRIAM: Amar?

GABRIELA: *Gura.* Anger. Bitterness?

MIRIAM: Oh. *Si.*

GABRIELA: But now on Nina's wedding, people forget all that. I'm so happy to see Vivi who moved to the other side of Sunset. Me and Carolinda smoke reefer with her

MIRIAM: Gabriela, you are smoking marijuana?

TEENAGE GABRIELA: Mrs. Miriam you always tell me I can say anything in writing, and it is safe—*seguro*—now it isn't okay?

MIRIAM: You're right, I guess, Gabri, go on.

TEENAGE GABRIELA: Me and Carolinda smoke reefer with her and find out all about the vatos in Angeleno Heights. She tells us how first they were pulling her hair, all the girls, and tried to start with her but now this boy Ramon nickname Payinadvance likes her and his sister is protecting her and some of the girls are starting to like her. Buts she says they don't have the same ways like people here. She says they have different ways. It's more noisy there, and you can't see the stars because the lights are brighter. It's a wild party night. We don't want it to end. Ever. I fall asleep on the front porch with *mi curandera* grandmother in a chair and me and Viviana and Carolinda on a blanket with all the cats of Calle Azulejo sleeping on our necks and the dogs on our feet. We are all nestled that way.

MIRIAM: Really?

TEENAGE GABRIELA: No, I just added it in because I liked the picture of it

MIRIAM: The image?

TEENAGE GABRIELA: *Claro.*

MIRIAM: Me gusta mucho tambien. Go on.

TEENAGE GABRIELA: Our Papas are still arguing and dancing. Our boys still playing music. Our mothers walking around,

talking. We wake up and eat all the leftovers from the wedding: corn tortillas, cold tamales, big plates of mangos with lime and pepper, pork tacos, dirty rice, cold beans. Our parents go to work. Us girls clean up. The people who don't live there anymore say their good-byes. It's a hot day and I know it's the last party of La Loma.

Why are you crying Mrs. Miriam? Is it your husband and that man?

MIRIAM: What? Oh no, no. It's your story.

TEENAGE GABRIELA: Fold it up tight and keep it for me, no?

MIRIAM: No. I mean yes, yes. We'll save it with all the others. Would you like some cheddarballs and triscuits?

TEENAGE GABRIELA: Sure.

MIRIAM: Well! (gets up) Let's celebrate!

NY Core-US

New York City, 2001

In Washington Square Park, two girls stop an elderly gentleman.

GIRL #1: Em, ekscuse me, do you know where the Pod Pond is?

CUTE OLD MAN: Pahdon me?

GIRL #2: (on cell-phone, splitting her attention) Pod Pond. It's like a-a what is it? It a bar, It's a bar-restaurant.

CUTE OLD MAN: Wheh?

GIRL #1: Where?

GIRL #2: It's on the corner. It's on the corner of Sullivan street and something else. Bleecker?

GIRL #1: Sullivan and Bleecker?

CUTE OLD MAN: Sullivan (cough) and Bleeckah. Aright. You go dowwwwn that street theh, yah make a right, after three blocks it's yur next corner. There used to be a uh uh uh—Do you know what? They used to have a place there where you could buy a fresh spaghett.

GIRL #1: Like pasta?

GIRL #2: Yeah, but he means like the kind you have—he means like, to take home and cook?

CUTE OLD MAN: Dat's right it was fresh spaghett and when you were sho't of cash the gen'leman who owned the place would give you a pa—a pohtion of it to take home at the end of the night. He fed everybody he knew when they were hard up.

GIRL #2: What. We're talking to this old—Okay! (off phone) Riley wants us to go. He says he's there.

GIRL #1: So, it's like that way, right?

CUTE OLD MAN: You got it.

GIRL # 2: Thanks.

GIRL #1: Thank you so much.

CUTE OLD MAN: At your soivice, madams.

> (He bows as they recede. They walk quickly toward their destination.)

GIRL #1: Oh that was such a cute old New Yorker type of man.

GIRL #2: Yeah I know it's too bad we weren't with Riley. We could've taped him on the palm-corder.

GIRL #1: Oh yah! That would've been so great!

GIRL #2: Yeah, it would've been.

GIRL #1: God, that old man talking about—what did he call it—spaghett? It made me all hungry I—

GIRL #2: I know. I'm starving, I'm starving. Once we get to the Pond, I'm gonna, like, order so much food.

GIRL #1: I hope they have, like, pasta?

GIRL #2: I'm sure they have, like, pasta dishes.

GIRL #1: Oh yeah. Sure.

GIRL #2: Turn here.

The Gardener

Los Angeles, 1990/1959

Ten-year-old Manny listens to *Bis-Abuelo*, his great-grandfather.

PAPA ZORRITA (*ABUELO*): When we sold that house to the government, I ploughed that garden under that last year. I said to myself, I'd rather do it. I don't want to see it get tore up. I'll just borrow a tiller.

I borrowed one from a nursery I worked for in Atwater and I just tilled it under. Burying that garden. That's pro'lly where they got the parking lot for the stadium now. That's probably just a numbered parking place. But that used to be some garden. We ate year round. My kids enjoyed that. Little Gabriela used to help me weed it. She was *mi favorita*—my favorite. She was a cute little tyke. She never forgave me for giving in to the authorities. Her and her grandma they stayed on and let the marshals drag them kicking and screaming. I told them you can do that honorably as women, but I, as a man, I'd have to take a stand and get shot, and I won't get shot for a baseball team. No. I've fought Hitler, but I won't fight City Hall. That's what I tried to tell them. But they insisted. I just kept going to work everyday, growing flowers and pruning fruit trees and sticking to the earth. She is as inconstant as anyone, but she is mine.

Manny Remembers Emerald Girl

Los Angeles, 1999

Seventeen-year-old Manny lies in the grass overlooking the Echo Park lake. His girlfriend Lavinia Esmeralda sits beside him.

LAVINIA ESMERALDA: (laughing as she is crying) Silly fool me! I thought we would survive. I thought this man is different. He's not like all those other men. All those other children who call themselves men. I thought you were different, Manny. I thought we would survive. No tears! Shit!

You liked me. It was you who liked me. I didn't even like you at first, I didn't even notice you. You picked *me* up, you picked *me* up at Denny's. You thought I looked cute in that uniform. I hated that waitress uniform; you thought I looked cute in it. You picked *me* up! I didn't even like you at first—that's why I thought it would work out. I thought this ain't no ego bag full of shit muscle ego-man. No, you different, you a little skinny nervous guy, and it's gonna work with you. An' now why you have to go do something I can't take? I thought you were positive. You played music, that's a positive thing. Now why you have to go do something that I have to—I can't stay with you, you can't do that. That's not positive, Manny. I can't stay with you no more. Why you have to do something I can't forgive you for?

No Room Left

Los Angeles, 1959

Mr. Wentworth calls urgently to Dreyfus who is high atop his sculpture on a windy early morning.

WENTWORTH: Dreyfus. Oh, Mr. Dreyfus, will you come down?

PORTNOY: He won't come down offa his crapheap. He's been up there all morning tethering on articles from the Spanyo leavings. What paper hold you in your grizzled paw?

WENTWORTH: Here, read it. It concerns your nemesis and his construction.

(Portnoy takes the crumpled paper from Mr. Wentworth and reads it aloud.)

PORTNOY: December 3rd, year 1959. By order of the City of Los Angeles Health Department. To Mr. Samuel Wentworth—that's you.

WENTWORTH: I-It is indeed.

PORTNOY: —recorded owner of Plot 12, section M of the Elysian Park Zone Lands. We hereby notify you that the structure found on your property is not permitted use of your land zoning. It is in violation of...I can't read this damn print. I need t'go and git my spectacles.

WENTWORTH: Oh, in God's name there's no need to read it my dear man. (He grabs the notice back.) They demand that we remove Mr. Dreyfus' art-sculpture. The 'eyesore to God' you so despise.

PORTNOY: What? Are they evasculating us along with the Spanyos? I thought that suit-and-hat man told you they weren't usin' our parcel for their housing works.

WENTWORTH: Portnoy, if you'd ever consent to read the newspaper or stop closing your ears when I discuss the days' events, you'd know that in our city's last several elections the noble-intended suit-and-hat men and all of the grand plans that went with them were defeated.

PORTNOY: Then why these half-score years have they continued to evake the Spanyos?

WENTWORTH: Precisely, dear friend, precisely. Why?

PORTNOY: Quit riddlin' me ya damn atheist, and say why!!!

WENTWORTH: Well, now they have sold it to a ball team from out east. They will be building a grand-scale stadium.

PORTNOY: Whar?

WENTWORTH: There.

PORTNOY: But there's a high hill smack in the middle of that valley.

WENTWORTH: Well, as a former, uh, engineer I can assure you they will find some resourceful manner of removing that hill. Alas, we are permitted to stay and watch the hill crumble along with Mr. Dreyfus' monument to the great unconscious mental oneness.

PORTNOY: And will you stay. Mr. Wentworth?

WENTWORTH: Look I see them coming. I've had this paper for a month. I couldn't tell him. MR. DREYFUS COME DOWN COME DOWN, I SAY!

(The city men arrive and wordlessly begin destroying the sculpture. Mr. Dreyfus clings as his tower sways.)

WENTWORTH: Stop that please, you *mus*n't this is un-Constitutional it's—

DREYFUS: No room. No room left down below. No room for dee angews. NO ROOOM NO RRROOOOMMM. DEH'S NO ROOM LEF FO DA ANGEWS. NO ROOOM NO ROOOMMM. DEH'S NO ROOM LEF FO DA ANGELS. AH! AH! AH! AH!

The sculpture tower falls.

The Patron Saint of Pill Heads and Pig Dogs

Los Angeles, 2001/1959

Gabriela sees herself with Chucho.

GHOST GABRIELA: Stars in the sky were so bright in the valley. *Abuelo* said it was the well effect. Down here in the basin of the canyon, all the lights in the city were blocked off and it made it darker than the bottom of a well. Stars stood out. The one street light way high up on La Loma shone over our heads. From lying down here, it looked like spots were floating out of my friend Chucho's head. I knew my friend Chucho would never survive out there. Inside here, he was a hill spirit, he was a boy of creeks, of dirt, of birds.

For sure the *pachucos*, sometimes they would rough him up a little bit, tease him, but they were superstitious, too, they knew that he was a little bit touched—so untouchable.

But out there, out there, outside of Bishop, Palo Verde, La Loma, it would be a different thing. They wouldn't know him. He was gonna float like a leaf on the ocean. He would not survive.

I was thinkin' all that as I was stareen at him. I'm high as a kite and for at least a minute, I thought he was a saint. Yellow dots are coming out of his ears. San Chucho of the Reds, I'm thinking, patron saint of pillheads. And he's taking gulps of the Arguno wine like a *coyote*, and then he's crawling in the mud, tearing up the mud, making sounds like a pig-dog, which was one of his creations… '(making a pig-dog oink woof snuffle noise) Oh *mamita*, oh *mamita*! Come here to your little pig-dog. Come here to your pig-dog.'

I crawl over to my friend Chucho: Yellow dots spin out of his ears in a halo. 'Oh piggie, oh *cariño pigito*, what can I do for my little pig-boy?'

Chucho paws up my chest with his front hooves. Now he's in a fizz of purple and yellow sparks. I look in his dark eyes— were they the wells? They seem to be dark wells *donde las estrellas*—the stars—could be seen always. I laugh in his face, his chin bumps against mine, I see the flash of my own white teeth

and then suddenly his mouth is on mine. I know he's my friend, but he's crazy. He's the untouchable and I'm the goodie goodie virgin, but his tongue is pushing past my teeth, tickling up the roof of my mouth as the night creatures make noises and the one streetlight over us glows like a glowworm's crawl of love. But we are not hot red like the pills we have taken, no, we are not red devils we are blue angels, now we roll in the grass, not burning but growing, a flower of tongue connecting the stems and into our skulls come attar of roses and into our mouths come honey-suckle vine. Now roll we in the grass, we, honeysuckling each other's throats, going down deeper and deeper, now we roll over dry scrolls of eucalyptus bark and fall to earth, we fall to earth, we fall, we fall down a hill and through three barrios, in a wheelbar-row of time, we careen through harrowing burials, we fall through basement floors and mildew cellars into chill and hollow asphalt guttings, until I lay at the bottom of the darkest well there was. On my back, staring. No stars.

NY Core-US

Brooklyn, 2001

F train doors open, the subway sighs and discharges.

CONDUCTOR: Coney Island, Stillwell Avenue, last stop.
CHILD: *Mami, mami* look all the rides ah open—all the rides look! All the rides ah open.
> (The waves pull in and out, a little boy screams and giggles
> in the capsizing waves, seagulls cry.)
MOTHER: (softly) Miguel, *vamanos*, Miguel!
> (A vendor carrying an ice-chest walks the beach.)

VENDOR #1: (robust) *Agua!* Sodas! Cor-ro—nas!

(Time passes. The Wonder Wheel turns, the passengers on the Cyclone Roller Coaster squeal. The little boy keeps playing in the surf. Seagulls coast the air currents, circling and crying.)

MOTHER: (still softly)) Miguel, *vamanos*, Miguel!

(The little boy laughs. A second vendor passes by.)

VENDOR #2: (Tired, flat) *Agua!* Sodas! Cor-ro—nas!

(More time passes. The little boy jumps in the foam. His mother calls again, a little less softly.)

MOTHER: Miguel, *vamanos*, Miguel! *Ya te lo dije.*

(A third vendor passes by.)

VENDOR #3: (meek and sad) *Agua!* Sodas! Cor-ro—nas!

Hannah's Dream

Brooklyn, 2001

Hannah writes an e-mail.

HANNAH:

> DATE: 8-29-01
> TIME: 04-colon-45-colon-26 EST
> TO: Klugdude@globix.com
> FROM: HaHaHannnah@xerxes.net
> SUBJECT: Quicksand

Dear Josh,

It's four-thirty in the morning and I can't sleep. For the third night in a row, I've been dreaming of quicksand. I figured what, what time is it over there for Josh in Korea? No doubt you are in

the middle of another very hi-tech micro-fiber chip day. Sorry—it's just my only source of pleasure right now to tease my more successful little brother. Oh, good news: my seventy job resumes have at last resulted in a bad underpaid job with no security. Which is great. Imagine if it were a well-paid job with security. Then I wouldn't be able to quit in three months. Yay!

Joking aside, I think Aunt Mir's coma crisis is lifting me out of my depression. I've been reading her all of her letters. I feel like I'll find the key and she'll wake up and say 'that's it—the key to me the meaning of my life!' But that never happens, she just lies there. Perversely, looking content and happy and maybe she's better off in a coma... Maybe some resting point between life and death is the best place to be. Maybe it's better than life or death. Maybe it's the median of the tree of life, the core of the Kabbala. I've been praying again, feeling Jewish again.

I forget the *Post*, WBAI, and Reverend Al Sharpton, Mayor Guiliani and his asinine sympathy. If he really cared about 'All that the relatives of the victim are going through,' he'd stop the city tearing up the streets all along Union from Grand Army Plaza to Fourth Avenue. Those bastards wake me up with their jack-hammering at six o'clock every morning. I think this morning I'll pour hot olive oil on their heads. No, olive oil is too expensive.

Speaking of olive oil, the quicksand dream: In reality, the whole middle of the street is blocked off by cement dividers. In the dream, there are people eating at outdoor cafes between these dividers. Very fine pasta and salad dishes, with baskets of assortments of freshly baked *foccaccia* and whole-wheat peasant bread. They're eating gourmet pizzas and I'm trying to tell them, they're in quicksand, they're going to sink but you can only communicate with them on cell phones and no one walking by will give

me their cell phones to use because they're ignoring everyone and just talking on their cell phones. Then there are people who don't have cell phones, old people in walkers and street people and new immigrant people and they're all drinking Chock Full O'Nuts coffee and they're shouting to them too, but it doesn't work they just can't hear. Then it happens—the people sink in quicksand—they're just sucked down. It's this horrible thing: one minute their mouths are full of gourmet pizza, next minute their mouths are full of sand. Now they see us, but it's too late. And then, it happens again: another set of cafes and people appear. This time it's all gelato and tall desserts. It happens again and again and again and again.

So I'm up. I can't sleep. Aunt Miriam can't wake up. The city can't figure out who did it. I'd leave New York if Aunt Mir weren't like this. I'd go somewhere. I don't know where but somewhere else. Josh I pray for you, you hi-tech atheist. Pray for me even though you can't. Fake it.

Your big sis,

Hannah

SEND!

Gabri and Payinadvance

Los Angeles, 2001/1959

GABRIELA: So, there I am three months *embarasada*, Chucho in the county mental ward, and I decide to go to the Lawsons drugstore downtown with my homegirl Carolinda and we hear from a boy they used to call Payinadvance that Mrs. Tromble was going back to New York. They're having a big sale back up on

Hummingbird Terrace where she lives. I made this boy Payinad-vance drive me back up there. They had just discontinued the Echo Park Line so I couldn't go by myself on the trolley like I wanted to. So Payinadvance drove me in his sharp black Chevy. Mrs. Miriam was gone. Her husband was there with another man drinking. They were fags. I knew that from the time I first met him when I was little and always wondered why a smart lady like Miriam didn't know. When I got older, I understood that women pretend things to get through it; then, when they're done pretending, they leave. Miriam liked to play pretend—she didn't tell me, oh Gabri stop telling lies, *mentirosa*! She always nodded her head oh? Uh-huh, uh-huh, then what happens next, Gabby? Uh-huh? Oh! That's splendid! Just splendid! She liked that word. How splendid that is! She said that at the sunset every time. *Todo el tiempo.*

Esmeralda and Manny Breakup

Los Angeles, 1999

LAVINIA ESMERALDA: Remember that time when we, we was on the freeway at sunset and we bonded together, I told you all about eating all my caramel flan when I was a kid waiting for my moms and the sunset was blinding us and you was wearin' those funny sunglasses? Why can't that be enough? Why do things always have to be changing all the time, oh, Manny, honey. *Mielo, mielo mia.* Squeeze me. Squeeze me one last time. Oh, Manny.

You know, I was up when I met you. I was way up. I didn't have a boyfriend for seven months and I wasn't down about it. I was up. I was reading all those self-help books, and they were helping me.

My attitude was good. I was magnetizing, leaving my grandmother's, getting out of Denny's. And it was working, too. That person came and just out of nowhere asked me to sit in at that class at USC and I did, and I go there and I was all, 'This is me! This is for me!'

MANNY: You could still do that, Lavinia Esmeralda.

LAVINIA ESMERALDA: Ya, I still could. I still could. But you ruined my happiness. You came along, and we were happy, were like two little birds drinking out of the same feeder. We were happy together.

Yard Sale on Hummingbird Terrace

Los Angeles, 2001/1959

GABRIELA: Mr. Tromble said she moved back to New York. He gets all sad-faced seeing me, 'It's Miriam's friend. It's Miriam's little daughter.' But I wasn't her friend, I said, and I got my own mother. Suddenly he gets possessed: Take everything, he says, I want you to take everything. Take it all away.

His boyfriend goes to him: Ah, knock if off Lonnie, what do you think this is, Day of the Locust!? And I go, naw, but Payinadvance goes 'mon Gabi, 'mon, the man said *take* it. Your family needs furniture. Payinadvance wants me to take this big oak dresser but it wouldn't fit. He gets me Miriam's tacky bamboo record cabinet with a whole bunch of her records inside. She had funny musical taste. A big *mezcla*. He wants the stereo hi-fi too, but it turns out Lonnie's boyfriend decided he was keeping that. I guess Lonnie's boyfriend wasn't as red as he was. So I took the kitchen table. *That* was true red. Red top marblized formica. Payinadvance got it in his trunk.

I carried it with me when I moved out of Gladys and Armando's and got married to Frank Hauptman. Frank wanted to buy a new table for me in the 70s. I said no, I'll just keep this one. Never heard from Miriam. Never tried to write her or call her. But I kept her table. I fed my kids their cream of wheat at it. Fed Manny and my other grandkids their frozen juicy pops and what have you. I kept her table. Now there I lie but don't R.I.P.; instead, I fly...

Gabriela flies over Echo Park Lake. She finds Manny and Lavinia.

Esmeralda and Manny Breakup

Los Angeles, 1999

LAVINIA ESMERALDA: You just lay there, such a talented person, you just lay there. It's like your Grandma Gabriela says, you don't do nothing, you just lay there. Manny, we could have survived. But now you just make me sad, you make me sad all the time. I'm gonna leave you. I'm gonna have to go now.
MANNY: Going, going, gone.
LAVINIA ESMERALDA: We coulda survived, you just fill yourself up with clouds.
MANNY: Ah, you a poet, Emerald-girl.
LAVINIA ESMERALDA: Ah, (laugh) you're my sweet love, Manuelito.

(Gabriela strokes the faces of the two young lovers.)
MANNY: I'm sorry, I only love you.
LAVINIA ESMERALDA: No, you don't, you love clouds full of rain.
MANNY: *La lluvia.*
LAVINIA ESMERALDA: Whateva, bye.

Lavinia leaves him. Manny stares up at the sky as Gabriela's ghost flies away.

La Lluvia and Coney Island

Los Angeles, 1945/ New York City, 2001
Ghost Gabriela sees her five year-old self running in the rain.

LITTLE GABRIELA: *La lluvia!* Wet, wet, wet—*mojada*! Wheee whee wheee! Tree! Tree! Tree! Bark wet and da sky wet wet *lluvia lluvia llueve llueve*!
LITTLE GABRIELA: (shivering, chattering teeth) *Sí, sí, sí, sí.*
CONEY ISLAND MOTHER: Miguel! *Vamanos*! *Ahora*! *Vamanos*!

CONDUCTOR: Coney Islar

(Subway hiss.

LITTLE GABRIELA: I seeeeeeeyou, Senor Skunkito. Euhhhh you stink. Hah Ha ha wet bark from dee tree, wet dirt gets all over me. Wet clover floras, wet brook, wet yerba buena, wet leafs, wet verde green verde. My nose smell it my nose se lo huele.La lluvia jump jump jump

MOTHER: (softly) Miguel, vamanos, Migu

whee. Shake a shake da tree I gonna get wet toda mi cuerpa all over my body. I gonna get wet. You be a angel and rain down dee wa wa from dee cielo gracias la lluvia gracias halleluvah la lluvia la lluvia

MOTHER: (less softly) Miguel, vamanos,

VENDOR #2: (Tired, flat) Agua! sodas! cor-ro-nas!

MAMI: Ay, Gabrielita! No-NO! Estas complemente mojado! Ven aca! Ven a tu mama!

tillwell Avenue, last stop.

VENDOR #1: (robust)
Agua! sodas! cor-ro- nas!

(LITTLE GABRIELA PLAYS SILENTLY IN THE RAIN)

I free I free I free-ah Oooo, mamita, hace frio hace frio wrap me—a like your bambina in a warm tortill-o hace frio hee hee hee pero me amo la lluvia!!!!!!!!! Fonda! You silly goat! Stop eating our garden! Hey mira, I am so wet. HA! Hi Mami!!

(Surf crashes, gulls

Ya te lo dije. cry, the little boy

falls and giggles in

waves.)

VENDOR #3: (meek and sad)
Agua! sodas! cor-ro-nas!

LITTLE GABRIELA: (shivering, chattering teeth) Hee hee hee hee hee.

MIGUEL: (Giggling, shivering, chattering teeth, he raises his finger.) One more time!

> Miguel screams with joy as he turns to meet a big wave and is enveloped by surf. The Cyclone roller coaster simultaneously plunges as the passengers shriek in unison.

WTC: NY Core-US

New York City, 2001

The World Trade Towers fall.

RADIO: We're seeing—we're seeing the second tower begin to collapse.

CROWD: Ah! Оннн! Holy shit!

CONSTRUCTION WORKER: An' not for nothin', I mean it looked like those roman candles, you know? Coming down? I mean holy shit. It came down like: (He demonstrates.)

> (His co-workers nod, fascinated by the physics of it, but also solemn.)

GUY IN THE MOB: (He walks in a stream of people up Eighth Avenue, who are passing 14th Street.) This is gonna be *such* a messed up day—*travel*-wise!

HOWARD STERN: I'm so upset. This is disgusting. I think we should go nuclear bomb them like we did to the Japanese. We burned the smiles right off their faces, didn't we, Robin?

ROBIN: Right, Howard.

TEEN ON CELL PHONE AT HER HIGHSCOOL IN MANHATTAN: Mom, I don't want to walk home to Brooklyn. (fairly matter of fact) Because they'll blow up the bridge? And then I'll die?

UPSET WHITE REPORTER: (interviews an African-American woman escaping ground zero) So, can I see? Are you hurt?

WOMAN: (lifting her skirt to show lower legs) You want blood? Here's blood!

> (A middle-aged Italian guy and young Hispanic woman wait to use a pay phone in Greenwich Village, in view of the crumbling towers.)

GUY: This is—it's totally unbelievable. It's like a movie. This is—

YOUNG WOMAN: This is about us going and getting involved in other country's business. We shouldn't get involved. People get upset. This is what happens.

GUY: I agree with ya, darling, a hundred percent, but what also should happen is people who don't belong here shouldn't come here no more.

Manny's Tattoo Vision

Los Angeles, 2001

MANNY: As I spin each vinyl, I see it like a saucer plate spinning in space, slicing sideways through people's heads, intersecting in discs like a slicer frisbee thrower and I come on my grandmother and a red-haired old woman entwined together and covered in a tattoo of everything: there is a tattoo of the black haired lady on the Viviana Beauty salon sign, there's a tattoo of a red cherry with drops spraying out. There's a tattoo of a big old greenfly with all the rainbow prisms on his wings, there's a tattoo of a Chinese mandala, there's a tattoo of a Ferris wheel. There's a tattoo of my mom crying when she told my grandmami and me she had cancer. There's a tattoo of me and Lavinia naked and holding with my cock all soft and quiet inside her. There's a tattoo of a cop standing on a boys shaven head and pushing his jaw into the sidewalk. There's a tattoo of

Guadeloupe mixing a balm for her children. There's a tattoo of an atom bomb killing about half the people in the city and their eyes as they light on fire and burn into walls as shadows. There's a tattoo of earth and a tattoo of worm, a tattoo that says mom with a heart, a tattoo that says Jesus with a heart, a tattoo that say Ku Klux Klan with a heart, and a tattoo that says Tracy, I miss you, come home, we need you, Ashley needs her mommy, come home, come home—Love Forever, Mark, with a broken heart. There's a tattoo of a hot-rod car and tattoos of numbers for gassing people. There's a tattoo of a rosebush, a tattoo of a tattoo artist making a tattoo. There's a tattoo of all the constellations of all the stars everywhere, and there's twisting vines everywhere to connect this tattoo of everything that covers the two bodies of *mi abuela* and of this strange white woman with hair like ruby sunflowers.

Angela Visits Miriam

Brooklyn, 2001

ANGELA: (lights up a lighter) Hey Mrs. M? You still out? Yeah, you still out. Dang you ain't even know what happen. The towers went down, Mrs. M. They took em out. Boom 'n boom, like dat. Dey showed it on the TV: wack ooooo ahhhh, like dat.

So now, Mrs. M, ain't nobody give a shit if me and my girls beat you or not. Dat's how I could visit you agin in the night like dis. Ain't nobody caring about me and my supposed alleged crime on you no more. Them cops that was tailin' me, they gone. Maybe they got took down by those twins, I do not know; maybe they cryin' on they girlie's laps. But nobody care no more about coma-lady and the Black Sunday Case at Ebbets Project, unh-unh.

The *Post,* the radio, the TV, all they care about is the dead people. See Mrs. M, you in a coma, so now people think, oh that ain't so

bad. Little old lady got beat up, maybe she wake up, and it's alright. See at least you ain't buried under all that mess you lyin' here safe in a hospital bed.

But I been thinkin' about it, Mrs. M. I been thinkin' about it an' thinkin' about it. See just like you in a coma and you still sung for me that time? Well I'm like that too. I could be knocked out but still doin' things. I go blank and I go inside other places and when I come out, I could be here there or anywhere. On that day you got beat on Easter Sunday, I went to Coney Island. I remember all that. Then I took a livery car back to Ebbets. Then you was lying up there in the walkway an' I was with all my girls and you was bleeding an people saw us an' we left you there. I ast my girls who did that? Who did it to that white lady? And they just said I o' know, I o' know, Angela. They was quiet and since den, they don't talk to me but dey don' talk to da police neitha.

Now first time I came to see you, I just wanted to see what you was like. You lay there quiet. I sneak past that nurse—she didn't even hear me! I watch you some. Your eyes shook like fish in a bowl. I thought, now if I did that to her, why I don't putta pillow on her face right now? But I didn't do that. No. I just told you about myself. 'Cos it seemed like you was askin'. So I told you and watch you breath. And then you sang that song. And that other song. You sang some. What you do that for? What place you at? You gone sing f'me again? I come here 'cause I like the music. Yeah, I come back to keep you cozy. See, no one care now if I did it. All they thinkin' is those twins. What do you think about what happen M.K.T. Flieschman? What do you think about it? I want you to sing. You singin'? Yeah!

MIRIAM: (In an off-key, wavering voice) I'm going to laaay doown my sword and shield, down by the riverside, down by the riverside, down by the riverside, I'm going to laaay doown my sword and shield, down by the riverside, I ain't going to study war no more.

Angela blows out her lighter.

PART TWO

MEGA MIXICANA WALTZ

Los Desterrados:

The Uprooted

Richard's Cab Ride

New York City, 2001

MIKE: Hey.

RICHARD: Hey deh, hic!

MIKE: Wheh you goin'?

RICHARD: Home I'm goin'—hic!—home.

MIKE: Where's dat?

RICHARD: Rockaway.

MIKE: Where in Rockaway?

RICHARD: Just take me to Rockaway. Take me. Just take me dere. I'll tell you when I want to get out.

MIKE: A'right. Not a problem.

Lavinia's Phone Call to Manny

Los Angeles, 2001

As Manny spins his solitary mix, the answering machine has picked up a call. We hear the tail-end of the outgoing recording.

HESITANT CHILD'S VOICE: *Deje un men-sa-je, por favor.*

(Family laughter cut off by a beep.)

LAVINIA: Manny? Manny? Mrs. Hauptman? Gabriela? This is Lavinia. I am just calling to see how you are doing. Everyone in Angeleno and EP has been out on the street or at Our Lady of Laredo since September 11th and ain't nobody seen—excuse me, I mean—no one has seen either of you since then—and for weeks before. So pick up if you are there. I just want to make sure you both are okay, alright? Hello? Manny, Hello, Manny I know you're there? Gabriela? Okay. Fine. Could someone please call my grand-ma and let us know you're—

MANNY: (turns down the machine, goes back to his cigarette and his mix) I didn't know, is it September 11th already? What is that? A holiday? Oh yeah, that's the date they started building Dodgers Stadium! September 11, 1961, *Abuela* always got pissed off on that date. She wouldn't allow any of us to go to a Dodgers game no matter what. Heh. Heh. See, *Abuela*, I remember that shit. You didn't think I was listening to you, but I was.

Lavinia, *mi abuela* is dead. For awhile I been making her a mix. Her body is still here. She doesn't smell. She's like an Aztec princess. I've embalmed her with music. Lavinia, if you loved me I'da picked up the phone and asked you to come over and listen to my mix.

Yeah! Seems like I dug up every left behind *recuerdo* in this *apartemento*. Yeah, I dropped a needle on every track. It's hot, too hot to touch.

(He ruefully glances at the machine and takes a shaky drag on his cigarette.)

Just like me, *querida*, just like me.

Miriam's Diary

New York City, 1959

November 1st, 1959

Diary,

It's strange being back in New York after such a time away. The train across the country gave me time to reflect. Tan desert, rocky mountains with white rushing rivers, endless fields of corn, then wheat, then corn again. More mountain barren black hills. Dark plains. Then one morning, green Illinois. Thoughts of our Adlai Stevenson. Why did we fail twice to elect him? His ideals seemed so fine and American to me.

Thoughts of failure became Lonnie. Why did I fail? I loved Lon so, I did. Inside I knew there was something wrong, but I didn't allow myself to know. What is that in us which knows and yet refuses to know? The same part that thought America would elect Adlai?

Lonnie. I ask myself how I could've allowed him to be so unkind to me these last years. Yet how could he be kind to me while being so much more infinitely cruel to himself? So, he is homosexual. So be it. Amen.

I feel an emptiness, a sore, cried-out feeling that isn't so bad. At least it is over. At least it's all come out. It reminds me of the feel and smell in the air after a grand show of fireworks. The explosions are spent, the sulfur dispersed.

Richard's Cab Ride

New York City, 2001

RICHARD: Hey, you got some cab here! You got all the playuz. Dodgers fan, hmm?

MIKE: Got that right. Brooklyn. Brooklyn Dodgers.

RICHARD: Me too. Me too. What is that thing?

MIKE: That's my Jackie-doll. Made it myself.

RICHARD: Ah, okay, yeah, okay, the Chock Fulla Nuts. Yeah, I get it. At first, I thought it was one of them, one a them things ladies put in da yards. A lawn jockey.

MIKE: No.

RICHARD: No, it ain't a jockey it's a Jackie. HA! (silence) Hey no disrespect to you or Jackie. 'Scuse me. I'm drunk. I had a few drinks.

MIKE: Yeah.

RICHARD: I'm a cop. We can't—hic!—get drunk no more. Not since that Officer Grey incident. Guy ran over dat pregnant woman an' huh family. I got a car. I left it. Wit the Grey case and then the Towiz, I don't want no more disasters!

MIKE: I could understand that point of view.

Viviana's Hair Salon

Los Angeles, 2001

Carolinda suspends the combing of Lavinia Esmeralda's hair and calls out to a girl leaving the salon.

CARO: Lisa! You going to Happy Tom's? Get me a hamburger like I like it with the *cebollas* and cilantro. And extra katsup. You want anytheen, Vivi?

VIVI: No, don't get me distracted. Don't get me distracted or I'm gonna burn Fifi's hair.

(The curling iron hisses as Viviana spritzes a hunk of Fifi the Transvestite's hair with a generous blast of hairspray.)

FIFI: Don't burn my ha-ir! Pleeeeaze don't burn my ha-ir, eez very important to me!

CARO: You better not burn him. It's already fritzed out beyond belief: it's like *Beyond the Thunderdome*, that hair. Don't burn it any more than it already is. It's—it's immoral, what she does to hair. Vivianna, it's immoral. I don't do things like that to people's hair, even if they beg me to. I don't do it. I have principles, not like Vivianna. I just don't do any old thing to somebody's hair, you know.

VIVI: Uh-huh. I do. That's why I saved my dollars and I bought this place. That's why the sign out there says Vivianna's Hair Salon. It doesn't say Carolinda-the-big-mouth-who-works-for-Vivianna's Hair Salon. No. It says Vivianna's hair salon.

CARO: That's right, Carolinda the-big-mouth-who-gives-you-half -her-customers. They don't even want to have you do their hair. Only me, right? Esme? Esmeralda, you come to see me, right, to see *Tia* Carolinda. You wouldn't let her do your hair, hmm?

LAVINIA ESMERALDA: I'm not gonna get between the two of you. I know better than that.

VIVI: Oh, yeah. She knows better than that, because when she was in tenth grade, she wanted her hair purple, she came to see Vivi, huh?

CARO: No! Is she the one that did that to your hair? That's terrible. Why do you do that, Esme? Why did you do your hair like that, purple. That's terrible.

LAVINIA ESMERALDA: That was back in the day, you know, that was back when I was called Emerald-Girl. I was just starting to see Manny.

FIFI: Oh, don't talk to me about Manny! Manuelito! Oh! That *cholo* could spin and scratch my turntable any time, mmm. (makes big kissing noise)

VIVI: Shh, be quiet, Fifi. Don't you know Esmeralda is still in love with Manny? Don't talk to her like that. She's a super-sensitive child. She's always been a super-sensitive child. So how is Manny?

LAVINIA ESMERALDA: (exasperated noise) I broke up with Manny a long time ago, and I'm not a child no more. You know, I prefer that you would both call me by my first name, Lavinia.

CARO: Oh, no, we couldn't do that, that's your grandmother's name. Also that would be bad, bad luck.

VIVI: Terrible luck, we couldn't do that.

LAVINIA ESMERALDA: Anyway, I don't know how he is, I've been doing a lot of spiritual cleansing in my life. That's how I visualized getting out of Denny's to a more upscale, Hollywood place, letting go of people who are draining—

VIVI: *Ay! Pobrecita* she's still so in love. It's terrible.

CARO: So you called him?

LAVINIA ESMERALDA: Yeah, I was thinking to call him.

VIVI: Oh, you see that!

LAVINIA ESMERALDA: No, because of September 11th I've been praying for everyone and thinking about everyone, plus I wanted to see how his *abuela* Gabriela is. I haven't heard from her. I haven't seen her in, like, weeks. You know, I haven't seen her anywhere.

CARO: Me neither. I haven't seen her, I haven't seen her at Vons, I haven't seen her in Pioneer… I haven't seen her for such a long time. She was always strange. She never did call very much, I mean.

VIVI: She used to call sometimes on the old festival days that we used to have at La Loma. She used to call over here on those occasions. Sometimes, she would call just to say hi. (sighs) That was nice, she would remind me of those days in La Loma, you know we were all friends, we all played together. Gabriela was like the leader— Gabriela, Carolinda, Viviana, we were the best friends in La Loma.

LAVINIA ESMERALDA: (teasing) Oh, yeah, I know. (in fake, melancholy sing-song) La Loma La Loma La Loma.

Fifi and Esme crack up.

NY Core-US

Brooklyn, 1955

Little Alan slides to the curb, pretending he's hitting a ball, then runs up the street, stopping at a front stoop and tagging "1st base." He catches his breath, backs up to the side-walk curb and shouts up to a third floor window.

ALAN THE KID: Viiiiiiiiiinnnie! Viiiiiiiiinie! 'Ey! Vinnie!

VINNIE: (Opening his window, leaning out.) Whaaaaaaa? Whachoo doin' Youse woke me up ya crazy kid.

ALAN: It's aftahnoon.

VINNIE: I worked all night. Whaddaya want?

ALAN: It's musical instrument night. I tole you last week, hah? O'Malley says ya bring a musical instrument of any type whatso-eveh and yiz get in fa fray. I'm bringin' my Pa's trumpet. Whatchoo gonna bring?

VINNIE: I ain't got nuttin'. I'm goin back ta sleep. Yiz go ta hell.

ALAN: Aw, caman! Youse can go t'hell! Ain't ya sista gotta kazoo?

VINNIE: Oh. Yeah? So what?

ALAN: Yeah, so get dressed come out hih an bring da kazoo! Dis is strictly not ta be missed! About a million intruments'll be theh. An' we'll all play. Dem bums are gonna shit a brick! Dey'll love it.

VINNIE: Aw shaddap dey'll lose anudda game, mark my words.

ALAN: HA HA! No, come on, come on!

VINNIE: Aright, aright, hold ya hahsiz.

ALAN: An bring ya sista. Alotta girls ah comin' tonight. Even Kominsky's Ma is comin'—

VINNIE: Wha? The polack's mutha? I taught she can't stand baseball.

ALAN: Yeh, but she plays accordion. Who knew?

VINNIE: Dis is crazy. A'right I'll be down in a while meet me at the candy staw.

ALAN: Awhile!? HAWRAY UP! THEH'S A LINE AROUND DA BLOCK AREADY!!

VINNIE: Aright aright ! I'm comin'! Don't lay an egg.

He slams shut the window.

Angela, Miriam and the NY Buried Core-US

New York City, 2001–1969

ANGELA: Maybe I got ghosts inside my head ghosts fillin' me up and talkin' inside me I been hearin' 'em since I was little. I heard all kines. I hear men buying subway tokens for ten cent, and old Jew ladies hangin' up they sheet. And the day I saw you got put in your coma, I heard this crazy loud sound when you was lyin' there. I heard people screaming and horns and violins an' 'cordions an' toy pianos an' drums and shakers all playin' the same time. *Bah Dump da dump tee da! Bah Dooo Dooo Dee Wanh wanh wanh PwaSh! Bam! Boh—O!* Like dat. Yeah!

MIRIAM:
(singing)

UPTOWN A TRAIN, 1979, SUBWAY

JAMES: Marcus!

Oh you can't scare me

MARCUS: Yo' m'man how you doin' baby?

JAMES: Aright, working down there on 42nd—

MARCUS: Yeah? I heard that.

JAMES: Yeah, I'm still where I was at before.

MARCUS: Yeah, you still workin' there in the, uh, garment distric'?

'm sticking to the un-ion,

JAMES: Yeah, my brother, that's it, you do what you can do to keep it goin'.

I'm sticking to the un-ion,

MARCUS: That's right, right, keep it movin', that's how you do it, keeping it simple.

I'm sticking to the un-ion.

JAMES: Dat's right. Keep it like dat.

Oh you can't scare me

I'm sticking to the union,

LOWER EAST SIDE, 1981

I'm sticking to the un-ion

LOISIDA 1: Papo papo papo, wheh's papo?

LOISIDA 2: He's by the rivah.

LOISIDA 1: Papo went to the river.

LOISIDA 2: Yeah, he over by the park the river.

LOISIDA 1: What he go there for? I'm lookin' for him.

LOISIDA 2: Aright.

'til the day I Die....

I'm sticking to the un-ion, I'm sticking to the unior

CARROLL GARDENS, 1973 to the union, til the day I Die....

Ices, get yah ices. Only a dollah cherry lime tutti frutti
melon ices—get y'ices hihya—

Oh you can't scare me I'm sticking to the un-ion,

> **MARCUS:** Good to see you baby, I'll see
> you around.
> **JAMES:** That you will, cat, that you will.
> **MARCUS:** Aright.

Ices, get yah ices. Only a dollah cherry lime tutti frutti
melon ices—get y'ices hihya—

HELL'S KITCHEN, 1983

Oh you can't scare me I'm sticking to the un-

> **BUSHY:** PONZOOOOOOOO
>
> I tole you ta tall him ta gimme da twenty dolliz. Now what da fuck
> am I gonna tell Shaun? No, no, because he's a mean asshole an'
> he ain't gonna listen ta dat shit. I'll listen to yuh shit but Shaun
> will just walk away. Oh fuck, now what are we gonna do?

Ices, get yah ices. Only a dollah cherry lime tutti frutti
melon ices—get y'ices hihya—

> Whadja do with the twenty dolliz I gavve ya?
> You did somtin' widdit, whadja do?

Oh you can't scare me, I'm sticking to the un-ion,

> Don't make me slap you. I hate it when you make me slap you.
> Hey Ricky, how you doin' aright? Aright.

I'm sticking to the un-ion, I'm sticking to the un-ior

Ices, get yah ices. Only a dollah cherry lime tutti frutti
melon ices—get y'ices hihya—

u can't scare me I'm sticking to the union, I'm sticking

LOISIDA 1: Aright, if you see him, tell him I came by.
LOISIDA 2: Aright. But he's by the rivah, aright.
LOISIDA 1: Aright.
LOISIDA 2: Aright, I tell him if I see him.
LOISIDA 1: Aright later.
LOISIDA 2: Aright.

sticking to the un-ion, I'm sticking to the un-ion,

WASHINGTON HEIGHTS, 1985
GIRL 1: Lizette, Harwray!!! Harwray! Hawrayyy! Hawrayy!
GIRL 2: Whaat?
GIRL 1: Harry Up!
GIRL 2: Just wait, dag!

I'm sticking to the union til the day I Die....

CARMINE STREET, 1969
ITALIAN GRAVY LADY: So when we get back, I make the macaronis,
I make the gravy and he says he ain't gonna eat tonight. I say, what I
made this for you, what you not going to eat since when you din't eat.
I said, if you don't eat it, it's a waste.

ESSEX MARKET, 1986
OLD LADY: Oranges yapples, I got fuh one dollah this whole bag.
This whole bag, one dollah. You gonna have to comeov, I make us
some-thing. A good baked apple. There's nothing simpler or better,
my mother taught me, than a good baked apple mit a little sour
cream. That's from the, from creation, creation give us apples.

ou can't scare me I'm sticking to the un-ion,

g to the union til the day I Die...

Richard's Cab Ride

New York City, 2001

RICHARD: Hey you from the old naybahood? Flatbush? You seem, I dunno, familiah tuh me.

MIKE: Oh yeah?

RICHARD: Yeah what's yur name? Uh okay, I see it, Michael Rafferty. Raffer—Holy Shit! Mike Rafferty! See dat! It's me. Richard Vallone. Richie. Sal's kid brother, remember?

MIKE: Oh yeah, I remember you. You tagged along with us dat time we went to da game in Phillie to see the Dodgers after dey moved to LA. We took the train and you tagged along.

RICHARD: I don't remember dat.

MIKE: Ah, yur better off. It was not a good time. We all felt lousy. Got sick on hot dogs.

RICHARD: Oh. YEY! Phillie! Now I remembeh.

MIKE: Yeah, Sal's little brother.

RICHARD: Yeah, Salvatore.

MIKE: I was sorry to hear about Sal.

RICHARD: Yeah, yeah well, 'Nam was a long time ago.

Viviana's Hair Salon

Los Angeles, 2001

CARO: (getting angry and serious) What do you mean 'La Loma La Loma La Loma?'

How do you know? Your grandmother Lavinia wasn't even from La Loma. We didn't meet your grandmother Lavinia til we—I met her when I moved to EP, when I had to move to Echo Park. We were all lonely. We were all apart. They called us *los desterrados*. The

uprooted. Vivi had to move to Angeleno Heights and I moved to EP. And your grandmother tried to pick a fight with me. It was very hard. I had to kick her *culo*. She was a pain in the mm-mm. Yeah, I had to fight your *abuela*. I remember it was raining. I left her crying on the sidewalk in front of your house at Morton Place. Then after that, me and her were friends.

LAVINIA ESMERALDA: You and *she*.

CARO: That's what I'm saying. Yes, after that we were friends but at first...you know, we didn't have friends. We were all separated. Especially Gabriela, she was the most lonely 'cause she stuck it out. Her and her grandmother—

VIVI: —The old *curandera*—

CARO: *Si, la curandera,* they were the last to leave. They got dragged out and put in jail. They were the last to leave.

Richard's Cab Ride

New York City, 2001

MIKE: Yeah, I didn't go to 'Nam. I got a deferment 'cos I had a wife and baby.

RICHARD: Yeah right you married early—married yuh sweetheart right?

MIKE: Yes I did, Debbie, the love of my life starting at age thirteen. We met at Ebbets Field, matter of fact. She was a girl just as into baseball as us guys. A great girl, she kept scorebooks and everything.

RICHARD: No shit.

MIKE: I shit you not.

RICHARD: So how's Debbie?

MIKE: She—auh—sh-she's moved up to Conneticut. We got divorced some years back.

RICHARD: Sorry to hear that.

MIKE: Yeah, well, like Vietnam, it was a long time ago.

RICHARD: Not like now.

MIKE: No, no, not like now. Now, now is now. Now is something else.

RICHARD: Oh yeah! You could say dat! Turned my whole world upside down, inside out. I'm a cop. I told you I'm a cop?

MIKE: Yeah.

RICHARD: I'm a detective!

MIKE: Congratulations.

RICHARD: Yeah, but my whole life, I did things a certain way. I never questioned it. Now I don't know which way is up, you know? Bombs. Anthrax. What's next? All those innocent people dead. I seen *dealiz* I know this week donatin' blood! I used to say da blacks were 99.9 percent animals but this week they're ALL my people. I keep askin' myself if I was to die tomarra would I want to be someone who framed an innocent man? F'rinstance, I gotta case right now my partner wants ta plant evidence on this Puerto Rican so we can close the case. Matter fact, the crime happened over on McKeever, where the old gate useta be, you know? Where you could sneak a peek at the game?

MIKE: Now I remembeh you. You were the one who useta charge the otha kids a nickel to look under the gate at da game.

RICHARD: Just the Irish and da Jews. I let the otha Italians watch fuh free.

MIKE: Well I'm Irish.

RICHARD: Yeah, I figure Rafferty.

MIKE: Yeh, yeh, the little kids useta complain about you.

RICHARD: Ah, *madonna, manajay la misere*! I feel bad about everyt'ing right at this time. Da whole world is turned upside down and inside out.

Missing/Neighbors

New York City, 2001/1941

TRIBECA, 2001

SETH AVI HERTZBERG,

OUR SON,

HAS BEEN MISSING SINCE THE ATTACKS.

THIS IS A RECENT PHOTO OF SETH.

HE HAS SHORT RED HAIR.

A PIERCED LEFT EAR. HE IS SIX FOOT TWO.

WE DON'T KNOW WHAT TO DO.

PLEASE CALL AT ANY HOUR OF THE DAY OR NIGHT IF

YOU HAVE FOUND OR SEEN SETH.

WE WILL GLADLY REWARD ANYONE WHO HELPS HIM.

HE IS A VERY SWEET, INTELLIGENT YOUNG MAN.

AGE 25. HE MAY BE UNCONSCIOUS SOMEWHERE.

PLEASE HELP!

HENRY STREET, 1941

RINI: Good morning, Mrs. Levitz.

MRS. LEVITZ: Good morning Rini.

RINI: Here can you help me vid dis sheet. You hold vile I pin.

MRS. LEVITZ: Olright. I heard Mr. Kaupof come in last night past midnight.

RINI: No vas he drunk?

MRS. LEVITZ: I don't tink so, but Mrs. Kaupof vas upset I heard cryink and yellink.

RINI: Hold this part firm, dah clothespin is tight here let me try. Alright now pull. Goot. Tank you. You got any tzing to hang?

MRS. LEVITZ: Noting but my husband's vork shirts.

RINI: Here, I help. I hold for you.

MRS. LEVITZ: Tanks.

NETTIE: Hello.

RINI: Who'd dere?

NETTIE: Nettie down below.

RINI: Ah hello Mrs Kaupof how are you zis mornink.

NETTIE: I'm tired I gotta big basket to dry.

MRS. LEVITZ: Vait, vee come down to your apartment and help you.

NETTIE: Dat vill be kind of you Mrs Levitz. This line is too tight and my husband don't fix it.

RINI: Vee vill fix it.

MRS. LEVITZ: Yes vee will help.

NETTIE: Tank you, you are kind.

RINI: No, we are neighbors. What else should ve do, hanh?

Miriam's Diary

New York City, 1959

<div align="right">November 3rd, 1959</div>

Diary,

I think I'm nearly unpacked now and feel a slight satisfaction and measure of comfiness for it. Of course, it isn't much of an accomplishment, as I shipped only a few boxes out from California. This little flat on Hudson and Bleecker is too small to accommodate much. Ester, however, is on fire—so gleeful to be out from under mama and bubbi and their stifling Flatbush ways. Tomorrow night, she wants to drag me to one of her folk-singing parties. Donate what you can for the insurgent 'cause in Cuba. I may go, if I can get my spirits to lift enough to dress for it.

Richard's Cab Ride

New York City, 2001

MIKE: I gotta suggestion fuh you.

RICHARD: Okay.

MIKE: Read *Heart-Glue*.

RICHARD: What?

MIKE: It's called *Heart Glue: the Seven Sacred Steps Ta Mending Yuhr Broken Heart.*

RICHARD: I don't gotta broken heart. I'm happily—well I don't if I'm *hap*-ily—but I'm married. I don't gotta broken heart.

MIKE: Nonetheless, I think it's applicable. You can get it at Barnes and Noble, Self-Help section. $13.95—'sgood price.

RICHARD: Is this by Deepak Choper? My wife has his book aready.

MIKE: No, no, I like Deepak but this one is by anotha lady Dr. Somebody —Dr. Jeanette Gladjnois. You know, it uh gets to dat feeling that y'have, y'know dat y'whole life has been blown scattered to fuck and back and, and uh how do yuh collect the pieces? And—

RICHARD: You go to da site?

MIKE: N-nnaw.

RICHARD: We got guys dead there in the department we can't even find their teeth—One of my guys, my precinct he was there twenty-four hours, day and night—told me they're loading up body parts on the dump trucks. I mean you don't even find their hands or anything.

MIKE: Uh-huh.

Dreyfus

Los Angeles, 1960

DREYFUS: Digga digga Digga: I gonnooo dig into da ho, dig da ho-ole, find ebryting, da towah fell down dee—da towah fell, dey put da greenfreshet and da goatie-goat bells and da dollies are all down deh in dah hole.

NURSE: Here he is. Delbert, you have a visitor today: Mr. Portnoy.

PORTNOY: Hey thar Mr. Dreyfus. 'Member old Eddie, from up on our ridge? Came ta see ya. Heh.

DREYFUS: Deeee angews dee angews from da sky is down deep I gonna dig adigga digga I gone get dem out. Nursie nursie you gonnoo hewp me ? You gonnoo hewp?

NURSE: Lay back, Delbert, it's time for your shot. Be a good boy today. Some day he don't even know where he at. He don't even know that it's 1960. You know? He somewhere else.

PORTNOY: I come to tell him our old friend Mr. Wentworth has passed over.

NURSE: I apologize, sir, he having one of those days.

PORTNOY: Well then, no sense in telling him I wager.

(exits)

NURSE: Lay back now. We know we don't want the electricity again, do we? Okee dokey?

DREYFUS: But I got to keep diggin digga digga…

NURSE: Mmmhmmm of course you do. But lay back or I have to call MR. JOHNSON the orderly.

DREYFUS: Okay Dokay, digga diggia digga. (laying on back pawing the air) Dig us out Out Out! Dig us out!

NURSE: Yes, that's it.

Johnny Lozano Missing/NY Buried Core-US

New York City, 2001–1941

LITTLE ITALY, 2001.

HAS ANYONE SEEN JOHN LOZANO THE THIRD?

LITTLE ITALY, 1954
POPS: You lay the brick lika this, thenna you
smoot it, chuk chuk chuk, lika da, ok? Now youa

JOHNNY WAS LAST SEEN try... Yeah dat's ita, dat's ita we gonna makea
brickalayah out oh you, yeah?
LARRY: aright pops don't lay an egg it was one brick
POPS: soon it's a gonna be a wall you see you see.

RUNNING DOWN THE STAIRS IN THE SECOND TOWER.

HE MAY BE WANDERING AROUND SOME PLACE OR IN A

LARRY: aright lemme alone awhile, yeah?
POPS: alright i leave-a you alone. You learn vincen-
zo, my son lorenzo he's a learnin' he's a doin good.

HOSPITAL WARD MAYBE IN SHOCK OR INJURED SO THAT HE

LARRY: larry pops
POPS: you see, he's american likea dem but he's
a bricklayer like us.

CAN'T IDENTIFY HIMSELF.

CANARSIE, 1976
MAUREEN: mickey, i don't like putting my head on
ya shouldeh when my hayer is in curlers i told you

PLEASE IF ANYONE HAS SEEN HIM

MICKEY: put ya head on my Shouldah
MAUREEN: nao!
MICKEY: put ya head on my Shouldah

CALL TERESA. I AM HIS GIRLFRIEND I HAVE BEEN WALKING

MAUREEN: oh aright. There
MICKEY: no! Put ya head on my shouldah

THE STREETS FOR TWO DAYS

FULTON STREET STATION, 1947
ALTA KACKER: ten cents a token! Prices gone up?
CLERK: yep ten cents now

SEARCHING FOR HIM EVERYWHERE.

ALTA KACKER: oi vey. Next it vill be fifteen
CLERK: how many sir?

I LOOKED IN ALL THE MAIN HOSPITALS.

ALTA KACKER: vell, make it zree zen, i huv to go to
vork, come home and vone extra just in case yes?
CLERK: thirty cents suh

IF ANYBODY EVEN REMEMBERS SEEING HIM, HE WAS

ALTA KACKER: ach zis is too much, too much to pay.
CLERK: next.

WEARING A BLUE BUTTON DOWN SHIRT, A BROWN TIE

AND A GRAY BROOKS BROTHERS SUIT.

JOHN LOZANO THE THIRD, PLEASE, IF YOU READ THIS

COME TO MY APARTMENT. TERESA.

Viviana's Hair Salon

Los Angeles, 2001

CARO: So, when Gabriela came out of jail, nobody would talk to her. Her *Papi* was so mad that she was pregnant by Chucho de Cuckoo that he, he wouldn't let her go with them—

VIVI: They were in the valley picking apples. He wouldn't let her go. And then nobody would take her.

LAVINIA ESMERALDA: Nobody, for real? She was like homeless?

CARO: She had to stay with her sister in Angeleno, that's what happened. In that *apartemento apesToso*. And then when she had her baby I was the only one who stood by her at City of Angels Hospital. Otherwise, she would have been alone. Vivi didn't go.

VIVI: I was busy.

CARO: She was afraid, just like her family. They're all like that. They were the first family to leave La Loma. They sold out in the 40s. They left immediately. (snaps her fingers) Those people were like rabbits, a whole family of rabbit people.

(Vivi ignores Caro.)

So I stood by her, I stood by her. She didn't even want to have her baby. She just lay around all the time. I made her. I got that zoot-suiter they used to call Too-tall.

VIVI: That's riiight! They called him that because he was six foot two and they teased him that he was too tall to be a Mexican.

CARO: Yes. Too-tall. So I got him to put her in his Buick and he drove us to City of Angels and they didn't even want to let me go in, but I told those doctors, 'Listen, she just did time in your white jail and I'll be *damned* if she's going to give birth in solitary! You'll have to drag ME from here kicking and screaming if you think otherwise!' So after that, they let me in. And Gabriela didn't want

to do it. She wasn't trying. I kept telling her, 'Push! Gabri, it's going to be YOURS this baby.' That's why she named her baby after me, Carolinda.

VIVI: Even though it was *mala suerte*.

CARO: (ignoring her) Mm-hm. And that's why when Little Carolinda gave birth to Manny, *I'm la madrina. I'm* the godmother. He was a beautiful boy. I had such high hopes for Manny.

VIVI: (sigh) Mm-Hmm, me too.

LAVINIA ESMERALDA: (wistful) Me too.

FIFI: (lustful) Uh-huh! Oh Yesssssssssss! I remember one time he was spinnin' for the FT boys in Frogtown an' he was so high that—
 (Lavinia hits him.)

CARO: Manny reminded me of Gabriela when she was young. She was so different, right? Before, before everything happened, she was so different, she used to laugh a lot, she used to run around with that goat, she had that white lady also that liked her, she used to write her stories.

VIVI: Mrs. Miriam.

CARO: Uh-huh, I saw that lady, too, at the jail. When Gabriela was in jail, I went there with some people to protest it, and that lady was there also. *Vivi* wasn't there. Mn-Mm.

VIVI: No, I was busy.

CARO: Mm-Hmm. *Oye, Esmé:* Some of us went through a struggle, okay? Some of us did our nails. (Vivi ignores her)
 But I was there and that white lady was there, Mrs. Miriam, protesting.

LAVINIA ESMERALDA: See? She was a so-called early *Chicana* activist, and she wasn't even one of us, she was white. See, that's why I don't like it when people start to get prejudiced. Some of those people are good people too, you know? And especially since

this happened over there in New York. I don't care, you know, what color those people's skin was, they died.

Vigil to the Missing

New York City, 2001
On a chain-link fence in Union Square Park, people place flowers, candles, and messages.

CATHY: Liz Holahan is my godmother. In a way, she was kind of the godmother of all of Union Avenue, children and cats. We love her, as *her* love was endless: for children, for animals—she helped save so many. Liz, you made the best cookies. We can't believe you're gone, we all love and miss you.

Your neighbor,
Cathy.

BYRON LAWRENCE: Raed Mahallall had a wicked sense of humor. He delivered coffee, bagels and pastries to our office on the 44th floor every morning for two years. Every day he had a smile on his face. Every day he made us laugh. Raed told me he was a musician. He liked heavy metal. He liked TV. His favorite show was the Conan O'Brian show and he hoped one day to get on it. RIP, my buddy Raed, no one at Whittier Burke will ever forget your laugh.

Your admirer forevermore,
Byron Lawrence

JAZMIN: All of this sadness brings us together. We can find a way to bring peace to this earth. This must be a turning point for us.

Jazmin, 9-16-01

SAMMY: We're comin' for ya, Osama.

Sammy, 9-16-01

Crumbled Crap Heap

New York City, 2001-1941

Ground Zero. A fireman digs in the wreckage. All of the buried NY Core-US begins when he starts digging and continues.

(with convergence of buried voices below)

FIREMAN: DIGGING IN THE CRUMBLED CRAP HEAP, DIGGING! THERE HAS TO BE SOMEONE LEFT ALIVE HERE. A FINGER WITH A WEDDING RING ON IT, A LOST HAND. DIGGING, WE DUG, DUG THROUGH THE RUINED MESS, THE DUST, DIGGING. WE CAN'T BREATHE, WE CAN'T BREATHE. GIVE US MASKS! THERE'S GOT TO BE SOMEONE, SOMEBODY, MY BUDDY. HE'S IN THERE. DIG HIM OUT, KEEP DIGGING, KEEP IT UP, HERE'S COFFEE, HERE'S SOME GLOVES DONATED BY SOMEONE FROM NEW JERSEY. WHY DOESN'T THE PRESIDENT BRING US MASKS? WE CAN'T BREATHE IN THIS SHIT. WHY DON'T THE PLANES FLY IN SOME MASKS? WHY ARE THE ONLY DONATIONS FROM THE PEOPLE ON THE STREETS? DIGGING, DIGGING, DIGGING FOR OUR LIVES,

DIGGING, IT'S GOT TO BE IN THERE SOMEWHERE: THOSE PEOPLE, THE REASONS. IT'S GOT TO BE, KEEP DIGGING, DIGGING, DIGGING. WE'RE GOING TO EXCAVATE THIS WHOLE THING WE'RE GOING TO FIND THEM BREATHING UNDER THERE WE'RE GOING TO SING AND HUG. WE'RE GOIN' TO SING, GOD, THROUGH THE DAWN'S EARLY LIGHT. IN THE EARLY LIGHT WE'LL FIND THEM, THEY'RE ALIVE UNDER THERE, WE'RE GOING TO GET THERE IF WE DIG, DIG, DIG PAST ALL THIS. WE'RE GOING TO KEEP DIGGING, HAVA CUPPA COFFEE, HAVE A BOLOGNA SANDWICH, DIG ON BROTHERS, DIG ON. MY HAND HURTS! WHERE ARE THEY? YOU HAVE TO STOP JOE. YOU HAVE TO STOP DIGGING. STOP IT, JOE. STOP IT. GO LAY DOWN. NO I DON'T WANT TO STOP. I WANT TO DIG UNTIL THIS IS OVER.

The Diner

Los Angeles, 2000

MANNY: Aw, why'd you want to come here, anyways?

HAILEY: (Manny's junkie girlfriend, a smokey southern California blonde, from the Beverly Hills aristocracy. She has a constant nervous habit of chewing her nails.) Isn't this your old 'hood, Man?

MANNY: Yeah, but now they got this diner all tricked out. It used to be a regular old school diner. You know, with old lady waitresses an' shit. Aw, I don't like comin' here.

TRIXIE: (A large Valley girl, of evangelical Christian stock, with vamping, campy attitude.) Look at him he's trippin' just to be in Echo Park. I like it. It's still old school it's like a cute little seventies diner.

HAILEY: No, I'm seventies. This diner is more sixties.

AUDREY: (The beautiful, damaged daughter of a failed TV actress and coke-head producer. She has a high, affected voice.) You think so? I think it's like fift—

MANNY: It's been here since the forties, okay?! Let's order and get out of here.

XANDER: (A neglected gay kid from Malibu hippie parents, he is opening sugars and creamers and slurping out the contents.) Wow! He really doesn't want to be here. What are you trippin' on?

HAILEY: He doesn't want to be seen with us.

MANNY: The thought had crossed my mind, yeah.

AUDREY: Ooo, I like that chandelier over the counter.

MANNY: Yeah, see, now that wasn't here before, and look at these menus: the prices have gone way up. You used to come here and get 'riz and eggs for, like three dollars. Now look: it's seven ninety five and you could have soy *'rizo* on the side for a extra dollar. Oh man.

HAILEY: That's what I love about the man, he's so authentically from here. Chorizo and eggs. HA!!

(They all laugh at him.)

MANNY: Of course, I'm authentically from here. You're all from LA too. What are you talking about Hailey?

HAILEY: Yeah, but we're all fake authentic. You're all authentic authentic. Like, I'm all seventies with my vinyl jackets—

AUDREY: You drive a Trans-Am too.

TRIXIE: Right, and you smoke Pall Malls, that's very seventies.

XANDER: Your green eye shadow, too. I think it's very 1973. I saw a magazine from the seventies with eye shadow just like that.

HAILEY: Yes, and Audrey is very Thirties with her baby doll slips and her fur throws and Louise Brooks hair sort of Paris—

AUDREY: Wait wasn't that the Twenties?

HAILEY: It doesn't matter it's all retro, mixed. Retro is just one big hodge-podge. Like Trixie is *tres* Eighties—

TRIXIE: (stands up and shakes her ass) Of course, I work at it. Like my purple spandex?

HAILEY: It's the leg warmers *I* like. I've been trippin' on those.

XANDER: Manny what did you do in the bathroom? Your pupils are pinned, dude?

AUDREY: He's nodding off.

MANNY: No, I'm not!

HAILEY: Don't, honey, I'm trying to explain something. God, where's the waitress?

MANNY: This place is packed.

HAILEY: Anyways, Man, you are authentic NOW.

TRIXIE: He's authentic ghetto.

HAILEY: Yeah, but that's now, Trixie. That's not retro like us.

AUDREY: I disagree, Hailey, retro *is* now. Now is retro. That's how

it is, darling, take it or leave it. We are the future—the future is youth and their fashion and we are it!

HAILEY: Okay, Audrey, I know, but what is Manny?

TRIXIE: He's authentically lost. Ha!

XANDER: He's nodding out.

MANNY: (coming to) No, I'm not. Did we order yet?

HAILEY: Where is that slag of a waitress?

AUDREY: I see one over there with pancakes.

HAILEY: Is she ours? I want huevos rancheros with *soy* sausage.

XANDER: I love how you're a total degenerate, Hailey, but yet maintain a vegetarian diet.

HAILEY: Well, you have to maintain an aptitude for drug consumption, Xander. I keep telling you. That's why I do yoga, too. The heroin diet, it's like a regime! I should make a video!

AUDREY: (giggles) Waitron? Waitron girl? We need to order! We've been out partying all night and we need some food?

LAVINIA ESMERALDA: (back to them) I'm not your waitress but I'll send—(Turning around, she sees Manny.) Manito?

MANNY: Esme?

HAILEY: She called him Manito! Ohmygod, that's one-thousand percent authentico chola! I love it.

MANNY: (He stands up.) Fuck, what are you doing here? (He lowers his voice and speaks softly.) I heard you got out of Denny's and went to some upscale Hollywood place?

LAVINIA ESMERALDA: This is the place. All the Hollywood people come over here now.

MANNY: Yeah, I know. (He looks embarrassed.)

LAVINIA ESMERALDA: What are you doing here?

MANNY: We're just eating breakfast. It's good to see you Emerald Girl.

XANDER: Is that her gang name? Oh wow, this *is* totally authentic. Man, you are the ghetto bomb, dude.

LAVINIA ESMERALDA: But did you come here because of your *Ama*?

MANNY: No, no. Uh, I mean, yeah, I'm going to go visit her in the hospital soon, Emerald. I feel bad but I've been busy doing events. They flew me to New York to do a party. I been to Aspen, um, Las Vegas. I might go to London next month.

LAVINIA ESMERALDA: Manny, your *Ama* isn't in the hospital any more.

MANNY: She isn't? Where is she? Back at the apartment? That's good.

LAVINIA ESMERALDA: No. Oh. You better call Gabriela. Manny, your moms—Carolinda has passed.

HAILEY: Oh shit, who passed?

AUDREY: His mom.

XANDER: Wow.

HAILEY: Shit.

TRIXIE: Manny, that sucks. We're sorry, fuck, wow.

LAVINIA ESMERALDA: Call your grandmother, Gabriela, she's been trying to find you.

MANNY: When is the funeral?

LAVINIA ESMERALDA: It was last week at that funeral home on Sunset, you know the one run by Vietnamese people. Me and *mi abuela* went. So did your Uncle Mike, your sister Izzy. Your cousins. But now Gabriela is all alone. Call her, she needs you.

MANNY: Oh shit, okay. We have to go.

AUDREY: Wait. Don't we still want pancakes?

MANNY: No, Audrey. Let's go Hailey NOW.

(He turns back to Lavinia.) It's good to see you Emerald Girl. Maybe we could hook up.

LAVINIA ESMERALDA: No Manny, I don't think so.

HAILEY: He's not asking you *out*, he's *my* boyfriend now.

(Hailey and the others stand up and file out of the booth.)

MANNY: Shut up Hailey! Go get the car.

HAILEY: Fuck you, even if your mother died, fuck you, you junkie.

MANNY: Yah, look who called me a junkie, Hailey. Go snort up in the car since you're too afraid to shoot up for real and just get the fuck out of here while I talk to her, ok?

(Trixie, Xander, Hailey and Audrey walk toward the exit.)

Wait in the lot for me! Trixie, Xander, make her wait!

HAILEY: (Over her shoulder as she flounces out.) Fuck off. Nice to meet you, Emerald whatever your name is.

(They're gone.)

MANNY: Sorry. Can I call you at your grandma's?

LAVINIA ESMERALDA: No, I moved out. I can't talk to you.

MANAGER: Lavinia!

LAVINIA ESMERALDA: Sorry, Carl, one minute! I have to go, I'll be fired. Goodbye.

MANNY: I'm sorry about my Moms' funeral.

LAVINIA ESMERALDA: Is that all you can say?

MANNY: Whatever. Talk to you later.

LAVINIA ESMERALDA: No you won't.

MANAGER: Lavinia! Table Five!

(Manny leaves.)

LAVINIA ESMERALDA: Okay Carl!

(She turns to a booth full of impatient customers.)

Hi guys, I'm your server Lavinia, can I start you off with some drinks today?

Miriam's Diary

New York City, 2001/1959

Hannah sits by Miriam's hospital bed, digging in a box of
old papers.

HANNAH: Oh, here's the missing page, Aunt Mir. It was at the
bottom of the box. Mmm'kay.

November…

MIRIAM:

November 4th, 1959

It's quite late. I've been to the party. Ester's new folk-singing
crowd. Most a bit younger than I, not all. I'm flushed with red
wine, with singing, with flirtation I suppose. We sang Negro
spirituals, railroad ballads, Kentucky coal miner's laments, and
even a Mexican folk song or two. These last reminded me of little
Gabriela and the stories she used to dictate to me of the holy festival
days in La Lomer…

At first, I felt horribly shy. My little sis introduced me to
everyone and then disappeared into the back hallway with a Haitian
she's developed an awful crush on. I suppose I ought not be
shocked. I saw a bit of miscegenation going on in the Village jazz
clubs in the early forties when Lon and I were extant, but seeing
my little sister Ester Klinger wrapped in this tall handsome Negro,
and I mean literally wrapped, not just in his arms, but wrapped in
his long red and yellow and green scarf—Well, I had to step back.

I went and hid in their WC. I looked at myself in the scratchy
old mirror they had. My eyes looked timid and disappointed; my
mouth thin and bloodless. And the blouse I'd bought waiting for

the next train in Chicago suddenly looked a bit uptownish for this young folk crowd. I looked at myself and I thought: I look like a woman who has been unhappy for several years. Then I thought of Gabriela, her grandmother and the people of Bishop, La Loma and Palo Verde, and all they had lost and how they must continue. I told myself, Miriam Klinger Tromble, ugly or not, go out and have good time, damn it all! And I did.

Yes, I met a man I found, shall we say, interesting. Hy Flieschmann. Ten years or so older. Jewish. Very. We were both stumbling through all the singing. He told me he'd sung many of the songs on two bus-trips down south. He went down there to demonstrate for desegregation. He said that he's got such a bad ear, sings so out of key, that his fellow bus riders teased him he'd be able to sing perfect harmonies if only he could sustain how off-key he was. I found something wry and self-deprecating about him that masked a real confidence and exuberance, and I liked him immediately. He isn't as good-looking as Lonnie by far. But he made me feel part of things. He said I had snapping green eyes, where did I get them? I told him, from the eucalyptus trees of Southern Californyer. He was very interested in my life there.

He told me he never left Brooklyn. He still lives in Brownsville. I told him I personally couldn't wait to leave, first for the Village, then for the coast. Now back I find myself nostalgic for the childhood days running in fire hydrants, cadging pennies for egg creams, dodging the endless games of stickball. It's still there, he told me. Come back over the bridge sometime and see it. The new immigrants are marvelous. The Puerto Ricans have a drink sort of like an egg-cream—but better—it's got egg sure but orange and something else as well and it's known as a *Morir Sonando*. In Spanish that means To Die, Dreaming.

What could be better than that? —To live dreaming?—I said. 'A-ha,'
he said.

Then I'm afraid, at this point, everyone got serious and started
reading poems. Most of them were terrible but a few were good.
Ester's new Haitian friend, Harry, in particular, had a lovely
cadenced poem about a girl combing her hair in the morning—
well, it was erotic anyway. Something about she leaves the comb
soaking in the water glass, an eye reflected in a windowpane.

We got quite drunk and sang many more songs. Hy asked to
walk me home but I told him no. I walked home alone taking Leroy
Street because I love my steps on cobblestones. I hummed one of
those old spirituals and watched my feet find their path home.

HANNAH: (standing up and stretching.) I better go home now
too. I work tomorrow. Goodnight, Aunt Mir.

She kisses Miriam's forehead and leaves.

NY Core-US

New York City, 2001

A homeless woman sits against a wall on Hudson and
Bleecker, in the West Village, stuffing crumpled papers into
her shirt for warmth.

HOMELESS WOMAN: Y'all homeless now. Y'all lost your real
estate in that great big hole. Yih, that's fo' real. What's real about
real estate? I'd like ta know, I'd fucking like ta know. I useta have
a apahtment, it was in my family three generation. Aftah I got sick
I couldn't pay, dey trew me out. Now I'm on da street or I stay in
da sheltiz. I'm dyin' here all so's real estate could go up. Da healfy

economy fuh real estate. What's real about it? An' my apartment, my ole apartment, dey renovated dat shit: raised the rent so high no one want it. It sit empty while I'm out on da street. So what I want to know is what da fuck is real about real estate? I'm in a state, dat's all and it's call homeless as fuck, yeah. It's called bein' dirty and beggin' for a baf. It's called bein' out here in cardboard town, fightin' off these jokers tryin' ta rape and rob me. Do dey treat me like someone else in da same boat? Hey, a lady out here, need some protection? No way. No these clowns try to rape and rob, that's their response! I hadda a nice little TV—a color TV—we had it plugged into the streetlight, a few of us could sit and watch it? They stole that shit. They steal everything, just like the real estate agents: thiefs in another disguise, that's what they is. That is the nature of humans: lying, selfish, thieving, raping fuckheads. Yes! Now *that* is for real. *That* is real estate in Manhattan. If you want to know the truf, well I just told it to ya!

Viviana's Hair Salon

Los Angeles, 2001

CARO: There are white people, brown people, black, red and yellow people. Some are good, some are bad. The real question is are they willing to participate in a struggle?

VIVI: Oh now there she goes! Wandering off into her politics!

CARO: No. I'm thinking about Gabriela and why she changed.

LAVINA ESMERALDA: Why did she?

CARO: You know, it's funny. If La Loma hadn't got torn down, and Gabriela hadn't got dragged out of there, I bet she probably would have left on her own.

VIVI: Oh, yeah. She would have been the type to go away, make something out of herself. That was her type.

CARO: Yes, but since they dragged her out she stayed nearby her whole life.

LAVINA ESMERALDA: 'Cause she's like me, waiting for something to come back. Something that she had always wanted.

Torn Down Hill

Los Angeles, 2001

MANNY: I could call my whole stupid family, call Lavinia over, but it wouldn't bring us back together; we'll never be together the way we were. Maybe we never were. Except here in my mix.

So, I'm going to dig up our torn down hill, dig up that cold asphalt parking lot where *bis-abuelo*'s garden used to be and find that old door on Calle Azulejo and open it and put you back in there to rest, *abuela*, and you'll finally be home and they can't drag you out 'cause we'll ALL be there and eventually we'll fuck up their game, we'll haunt them, no matter how hard they play to win, how hard they beat their enemies, they'll lose. Their stadium will rot, just like your old body. It will fall and all become dirt and worms again. And the blue-birds of Calle Azulejo will eat the worms and fly away...

Richard's Cab Ride

New York City, 2001

RICHARD: But that was some old naybahood, wasn't it? Remembeh dose trolley cars? Used to go right by the hill, over by Ebbets Field?

MIKE: Oh yeah. And they came so close together y'had ta dodge between 'em. My Pa said that was why they named 'em Dodgers—the Brooklyn Dodgers.

RICHARD: Is dat right?

MIKE: Dat's right.

RICHARD: You're a—a regulah you're a regulah—

MIKE: Yeah, what am I?

RICHARD: You're a regular expert. This is like a mausoleum here. Who you follow now, the Mets?

MIKE: No one. No, I was the Dodgiz. The Dodgiz was my team. One-team fan. One-woman guy.

RICHARD: And they both left you! HA! Dat's why YOU haveta read that stupid book *Heart-Glue*.

MIKE: (Mike goes quiet.) Maybe so.

 (Silence)

RICHARD: Ah, I'm *sorry!*

MIKE: (Still cagey.) Not a problem. Not a problem.

RICHARD: See: I was always a mean bastard! You know what? You get a new one. My first wife left me, I got a new wife, now I follow the Mets.

MIKE: Nah, fuh me it was Brooklyn.

RICHARD: Well. How about da Cyclones then? Me and my partner Chuckie hadta go out to Coney. Chuckie, he don't know shit, he's from the Island. He don't even like baseball! He likes hockey and wrestlin'! But, so we went to Coney Island and they're fixin' it up. They got a whole uh, revitalization thing. Built a beautiful little stadium right there by the ocean. Beautiful. Very nicely designed. I said I'mna come back here with my grandson. So I did. Beautiful game. Beautiful. August 30th. And uuuhh…

MIKE: Did they win?

RICHARD: No, they lost but the kids had fun and that's what counts.

MIKE: That's what counts.

RICHARD: Yeah and afta the game they had fireworks. Over the boardwalk…was beautiful! Y'know? Beautiful. Fireworks goin' right over the ocean. Right there by the ocean and these little boys they were horsin' around, they were pretending to fall down with the fireworks. Jerking around you know? (He acts it) Tryin' ta pretend ta *be* fire crackers. Was great. Was a beautiful day. Was a beautiful night. It was—lemme off here, this is good.

MIKE: You live *here*?

RICHARD: No, gonna walk off the drink for the wife, walk by the water. Clear my head. You take care, Mike. Here keep the money. (He hands Mike a big bill, opens the cab door.)

Keep it. (Mike tries to give him change. He won't take it.) You gotta beautiful cab here.

MIKE: Yeah, well, Taxi and Limousine Commission don't like it.

RICHARD: Fuck dem dey got no imagination, da sour pusses! Dis is what da world needs: more of this! It's bee-yoo-tif-ful! See ya, keep yuhr bases loaded, Mike. Ha, ha, ha!

(He gets out, slams the door, stumbling away, as he waves to Mike.)

MIKE: (Mike unrolls the window.) 'Kay, Richid. Good luck investigatin' yuh case.

RICHARD: Huh? Oh yeah, the case. Yeah, thanks. Bye!

(He lurches off as Mike drives away.)

MIKE: Bye, Richard.

Stealing Bases

Bury This Mix
Los Angeles, 2001

MANNY: Two turntables twisting at my fingertips, dipping into purple and blue sounds, wrappin' my *grandmami* an' me like bleeding video colors. I want to go home. Yeah, bring it home with hot sound, a moaning beat, and a disco sword—swarm of Mariachi horns!—scratch—rainstorm!—scratch—buzz of metal!—scratch—running feet of *caribe* drums!—boom!

Stop. How about silence in this mix a moment of silence…

Shit, *Abuela, Grandmamita*, hear that? Hear that silence? Damn! I been mixing you this funeral song a long, long time. I'm done mixing. That's it. No more. It's time to bury this mix, (The phone begins ringing.) and it's time to bury you.

SHUT UP phone!

(Final ring followed by answering machine click.)

Duet

New York City/Los Angeles, 2001–1959

HANNAH: Okay where were we, Aunt Mir? December 3rd, 19—

MIRIAM: —59, Diary, love is such a funny, unfathomable event. How can one love such different people in one lifetime and yet remain oneself the same person? Lonnie was everything I thought I wanted. A handsome, dapper, uncompromising man. One who'd give me a hard time, expect the best of me, tease me into thinking harder. Most of all I swooned for Lonnie.

GHOST GABRIELA: When they had put me in county jail, in solitary, I looked into the dark and saw things. I saw that there was no point to me anymore. Sure yes, I would continue, I had a baby in my belly. But that was all I had. I wouldn't become a writer like Mrs. Miriam had thought. I couldn't go away somewhere, get educated and tell about just some people from some places. No, it was better to just go on, than to try to give back life to something so gone. So I nursed my *Carolindita*. She was a tiny dark, cute baby. She didn't cry very much at all but she had a cough—the air was bad in my nieces' room in Gladys and Armando's apartment I think it gave her that cough. So when I had enough money from sewing I would ride three buses downtown to Lawson's drugstore and buy her this special cough syrup. That's where I met Frank Hauptman.

MIRIAM: Lonnie had a languid quality at times. I could catch him in it on our deck, he'd sit there at sunset smoking, deep in himself and at those times he looked like a cat. I wanted so badly to reach out and stroke the fine fur, but as with a cat I knew it would disturb the magnificence of the repose. There isn't a languid bone in Hy Flieschmann's body or even a languid drop of blood.

He's more an everyday man. For example, he drinks his coffee with an awful non-dairy creamer and doesn't seem to notice. His apartment in Brooklyn is indifferently decorated. Utilitarian, yes, but in a comfy useful, not a Spartan way. I can't help but be reminded of other Jewish relatives—bachelor uncles with doily armchair covers given them by their mothers or sisters. And then, that strange, masculine habit of storing household knickknacks in tool boxes and coffee cans so that there's this mix of industrial and delicate with no thought to complementarities whatsoever. Lonnie wasn't like that. But Lonnie turned out to be homosexual.

If I married Hy Flieschmann, I could decorate as I pleased. If I married Hy Flieschmann!? Why would I marry Hy Flieschmann? He isn't my type, is he? What is my type? What type am I?

GHOST GABRIELA: Frank followed me out of Lawson's and asked to buy me donuts. He was a truck driver from South Texas. His father was German and his mother was a *blanca Mexicana* from Monterey. She died when he was baby and so he had a thing for Mexican women. He was about forty. Not bad looking. We went next door to a place going out of business where all they had left that day was donut holes. A lot of places downtown were closing because no one could get there easy and the freeways went to new places in other areas. And so all that was left was donut holes. I looked in Frank's sad, hazy, green eyes as he told me that he was a donut and I was a hole to fill his donut. My first thought was he is already missing something he won't ever get back, so whatever I give him he will accept. Just like he's dunking these donut holes in his coffee. He'll take what's left over. He won't ask for more. So I married Frank Hauptman.

MIRIAM: We had a date at Hy's apartment in Brooklyn. He bought a roast chicken and potatoes au gratin and a loaf of bread

and butter from his local grocer delicatessen and we sat and ate in his Brownsville kitchen. We could hear kids playing stoopball in the snow outside and housewives wrenching open their windows to call to them. I kept putting more butter on my bread. Lonnie used to call me a butter hog and tease me for how I salt my food. I noticed with glee that Hy was pouring huge amounts of salt on everything. I began to giggle. He looked at me innocently and said, 'Good, yes?' And I said, 'It's good, yes.'

GHOST GABRIELA: I had my own apartment. I had Carolinda. Frank was a good man and father. We had four more. I raised a family. For a while things could seem fine, but I knew they weren't. I would pray to God in church on Sunday to make things work out, but I knew He couldn't. So I loved them, I screamed at them, I held them. But the streets and schoolyards, even those cartoons they watched, held more *dominio* over them than all of me and God put together. One by one they went off. West Covina. East LA Glendale. Soledad State Prison. North Carolina Army Base. But Carolinda stayed. I had to raise her kids. She worked all the time cleaning for all those snotty *blancas* because her no good *Salvadoreño novio* had split town. And then some of her brothers and sisters would come by for a second and leave me with all the grandkids all weekend. So it was non-stop diapers, cartoons, screaming, fighting. In a way, I enjoyed it. No peace ever. But maybe a little joy sometimes.

In 1982, year of the skunk, that shit-head Manolo Senior comes back, gets Caro's hopes way up working odd jobs, then he falls off the wagon and leaves again. That year, Manny Junior is born and he is his grandpa Crazy Chucho and he is me, my personality, all rolled into one skinny, jumpy little ball. I loved this baby; I nursed him practically at my own breast.

Here was my downfall, this Manolito. He is everything I thought was gone.

He listens when I sing to him. He believes my kisses heal his bruises, even after I told him no, it's only pretend. It's not pretend he tells me, it's magic. And for the first time in a long, long, long time, I feel that chill, that thrill, that tiny pah! of heat from another heartbeat.

I tried to protect him from this world, but it could not work. I had to watch him wander around getting slapped by the world and he stopped listening to me, stopped listening to himself, stopped believing. He stayed on here, after his time with that white girl shooting dope. He came back to me when all had left, when Frank had passed away and Carolinda died from cancer. He stayed here. And stayed. And I watched him waste his days and nights, watched him roam a ruined world that wasn't made for him, but a world he had to give something to or else be ruined, as I had been. And still I watch him. I watch him, I watch. I can't leave.

MIRIAM: (She flutters around, sipping on something.) But you *must* leave Gabriela.

GHOST GABRIELA: Don't get hurt, Mrs. Miriam, but that is such a white atheist thing to say. I'm Mexican. I'm Catholic. I can't just leave.

MIRIAM: You see, I never saw you as that. I saw you as Gabriela the individual.

GHOST GABRIELA: (She does a double take.) M—M—Mrs. Miriam, what are you doing here? Are you dead too?

MIRIAM: No, not quite, I don't think. I'm in a coma.

GHOST GABRIELA: What's that you're drinking?

MIRIAM: It's, It's sort of a soda—ish thing. I think it's what they're putting in me back at the hospital. Would you like some Gabriela?

GHOST GABRIELA: I'm thirsty as heck, but the dead can't eat or drink. You're lucky, you're in-between. You get a soda. What are you doing here?

MIRIAM: I don't know. I've been wandering around riding the hoods of cars on freeways, hanging out by burrito stands, I even went back to the Forties and rode the trolley downtown. It felt like when you wander back into a party you've been trying to leave because you've forgotten something and then there you are wandering around looking for something left behind a hat a purse. Well, not a hat—I never wore hats, I never liked them.

GHOST GABRIELA: Uh-huh. So I-I'm a hat.

MIRIAM: No you're a purse. I never liked hats.

GHOST GABRIELA: You're not making sense, Mrs Miriam.

MIRIAM: Well I'm in a coma.

GHOST GABRIELA: Well I'm dead. (beat) I missed you.

MIRIAM: I missed you too. I sent you something when you were in jail. Did you get it?

GHOST GABRIELA: I smoked your letter. Me and an Italian girl made it into cigarette paper. We rolled strips and smoked it.

MIRIAM: I didn't write you a letter. I sent you one of your own stories. The first you ever told me.

GHOST GABRIELA: So I smoked my own story.

MIRIAM: Well, I saved the carbons in a box somewhere. My niece has been reading some of them I think. What is that odd, familiar music? Can you hear it?

GHOST GABRIELA: No.

MIRIAM: But listen…

Manny Takes Gabri

Los Angeles, 2001

The phone rings three times. The answering machine clicks.

MANNY: AH! Shut up, phone! Where are those flowers? Hold on. Yeah. They're in here in the living room where you never allowed us. Everything in plastic. Hey, I got an idea. Let's wrap *you* in plastic! Yeah. All your life you took all the abuse, all the wear and tear, while your furniture was wrapped so safe and nice and perfect. Now Maneulito going to wrap you with all your things! (He rips the plastic coverings off of all the furniture and dumps out all the vases of fabric roses.) Let's see...here the flowers. Fabric. Never going to die. (He smells the fabric roses.) No. Not like you and mom, these flowers going to live forever.

(The phone rings.) Stop ringing, you fucking phone! (It stops after one ring.) Finally!

Okay, lets go to the stadium. It's time for your burial. None of these other bunk *familia* members appear to be here so it's just me and you, *abuela*. The flowers look nice. Here go the family photos, frames and all. What else? How 'bout this nice cushion for your head? Here comes the plastic. Here we go. (He wraps her in the plastic covering he's pulled off of the living room sofa.) Shoot, I was always a little guy not too big but I'm strong I'll get you whup! Yeah here we go. (He hoists her corpse onto his back and staggers under her weight.) Car keys? Fuck where are the car keys? (He frantically feels around for his keys, trying to keep steady with Gabriela's corpse on his back.)

AH! I should have got them first before I picked you—and I need my mix, my *grandmami* mix, get the tape, oh yeah, okay—car keys!—here we go.

(Manny staggers out the door.)

Plant a Hat

Brooklyn, 2001

CHUCK: We'll plant a hat. Put some of the victim's blood samples on it, some hair. We plant it in the perp's room when we go to search her mother's apartment.

RICHARD: So suppose the old lady comes out of her coma and says she don't got a hat?

CHUCK: She ain't coming out of that coma she's been down for five months. She ain't—

RICHARD: You don't know that

CHUCK: And if she does—

RICHARD: See, you young cops think you're God—

CHUCK: And if she does, she'll I.D. the perp every which way and we don't need the hat. We'll forget about it. Just bury it.

RICHARD: Just like that. I'm six months from retiring and I could lose everything.

CHUCK: You know the perp did it. It's an atrocity. It's like Osama bin Laden.

RICHARD: Would you quit with that fucking comparison? He's got nuttin' ta do wit this case. Not for nothin' this kid mighta done it. Might not.

CHUCK: What? Remember the old lady's face? Kicked purple? Bleeding? She's vicious. She runs a gang of vicious females. They were seen near the body by 20 peop—

RICHARD: Yeah, yeah, but her social worker just told us she's mentally, uh, challenged. We interrogated her and she *is*. She's a kook! You yourself said she was like a transistor radio! The social worker said her and her ma got a genetic deficiency where they lose consciousness like narcoleptics.

CHUCK: You're saying this animal should get away with it because of a mental defi—

RICHARD: I'm saying if someone else wanted to get away with it ain't nobody better to make *look* guilty than kooky-ass little Angela De Mayo.

CHUCK: You're crazy!! You're too old for the job. You've been doing it too long.

RICHARD: You stupid bastard. Listen, when I made detective you were still in diapers! In Long *Is*land! Tryin' ta tell me when ta plant evidence. We'll plant evidence when *I* say so! And it won't be a fuckin' hat!

CHUCK: What then?

RICHARD: A bat. Make it a baseball bat.

CHUCK: A *baseball* bat!?

RICHARD: Okay! Okay! Make it a hat!

CHUCK: Good. I'll go get the warrant. There was no reason to beat that old lady, right? She didn't do nothing to nobody.

RICHARD: The reason was that she was old. White and old.

CHUCK: Right. So I'll go take care of the warrant. I already got the hat prepped in a ziplock bag.

RICHARD: Aright.

CHUCK: Aright Ritchie y'made the right decision, I'm tellin' ya.

RICHARD: Aright.

CHUCK: Aright, ya good. (Pats him on the shoulder.)

RICHARD: I gotta hangoveh.

CHUCK: Here, have a cigarette. I'll be back.

RICHARD: (takes the cigarette to light, then freezes) We can't even smoke in this friggin' place no more!!

CHUCK: Aright! I'll meet ya outside! (He stomps out with a slam.)

Miriam's Last Entry

New York City, 1960

MIRIAM: Diary, I haven't written for days. Yes, I've given way to Hy. We went for a walk in Prospect Park. The trees were all hung with icicles. The sun was so bright, it was a crystal day. I wore my Mexican shawl that I bought on Olvera Street back in Los Angeles. Hy said he'd never seen a more beautiful sight in all his life. Then we went back to his apartment. We left our boots by the hissing radiator. We began kissing, as we've been doing. This time I let myself dismiss his awkwardness and feel his warmth; his warm, desirous hands. His very warm, blue eyes.

I felt a bit awkward, yes, but I also felt as if I were about to lower myself into an endless spring of goodwill and affection. He kept saying that I was like a queen, but, being a good socialist, a queen that he had voted for. Queen Miriam the Magnificent, he called me. Miriam, Miriam the Magnificent. Miriam the Magnificent.

Hannah's Last E-Mail

Brooklyn, 2001

HANNAH:

> TO: Josh@Globix.com
> FROM: HaHaHannah@xerxes.net
> SUBJECT: scraping the pan

Dear Josh,

Remember when Mom would cook that chicken and rice dish baked in a pan? And we used to fight over who got that last burnt

greasy part you had to scrape out with a knife? Well that's how it is now with Aunt Mir's diaries and letters. Her diary just peters out at around 1961 after she marries Uncle Hy and moves in with him in Brooklyn. She keeps a diary still but it gets boring—basically just a datebook for all the political protests and meetings that she and Uncle Hy attended. Sort of like, like a grocery list for the left: 'Protest Robert Moses new development in Coney Island,' 'War Resisters' League,' 'Stop The Bomb Symposium,' 'Freedom Bus ride next month can we go?' Etcetera. And then there are those badly written articles in these little tacky papers she and Uncle Hy wrote for...

But even though Mom moved to Long Island after she married Dad, there are no more of those long, detailed 'Dear Ester' letters, like when Aunt Miriam lived in Los Angeles. Maybe because by that time they talked on the phone a lot. Mir always called on Friday afternoon. Shabbat, when Mom was trying to get dinner ready before the sun went down. She always said, 'Miriam, you atheist! Why are you calling?!' But she never stopped her. I guess it was their tradition.

But you know what? I don't think Aunt Miriam stopped writing because of phone-calls. I think she stopped writing because she was happy. After she married Uncle Hy, she stopped searching.

Me, I am still searching, scraping the bottom of the pan for yummy scraps, for burnt greasy pasts. She leaves off in the early sixties. My life began ten years after that and from there I know the story of Aunt Miriam.

I look at her asleep in that coma and I realize that she's okay. She's eighty-six years old. She's my aunt. I've done my part. I've seen her through. Who will read my life? Will someone scroll through the sent file of my e-mails one day? Will it be you, little brother?

Who am I kidding? Josh, I think this going to be my last e-mail for awhile. Come home if you want to talk, you asshole.

Love,

Hannah

SEND!

Lavinia and Machine

Los Angeles, 2001

Phone rings three times, answering machine clicks.

GABRIELA'S VOICE: Hello, you've reached the Hauptman-Vasquez residence. Please leave a message and we will call you back. Go ahead, Didi!

HESITANT CHILD VOICE: *Deje un mensaje, por fa-vor.*

(Family laughter is cut off by long beep.)

LAVINIA: (stands making call on street from her cell phone) Manny? This is Lavinia. Pick up the phone, Manny. Mrs. Hauptman?

Gabriela, if you're there, could someone please pick up the phone. I've been calling you for weeks, could somebody please pick up the phone? Manny this is serious. OK, I'm just gonna talk into your machine, then. You gotta do something, you gotta stay away from the windows right now. You gotta stay away from the windows. I hate to tell you this, Mrs. Hauptman, but Manny is in trouble—

SOUND: BEEEEEEEP.

(She calls again. Phone rings three times, answering machine clicks.)

GABRIELA'S VOICE: Hello, you've reached the Hauptman-Vasquez residence. Please leave a message and we will call you back. Go ahead, Didi!

HESITANT CHILD VOICE: *Deje un mensaje por fa-vor.*

(Family laughter is cut off by long beep.)

LAVINIA: Manny, it's Lavinia again. Listen, you got to listen to me, your cousin Val over in Frogtown, he just got shot. It's okay, Val is too fat to die. The bullet just lodged somewhere in the fat, but now he's in the hospital and he's saying he's gonna go and kill that Pee Wee that he thinks did it, over there, one of those EP boys, well that just happens to be the boy you and Val went to kill three years ago and you talked Val out of it? So now you better watch Manny because the Frogtown boys are mad at you I know because I was over at Vons and, and Shy-Girl told me that the FT boys were buyin' baby buds to celebrate the fact that they were gonna go and kill you. You gotta stay in your apartment. And Mrs. Hauptman, you gotta stay away from the windows in the living room because, because now they gonna come and look for you and I want you to know one more thing, those Salvador boys—

SOUND: Beeeeeeeep.

LAVINIA: Shit!

(Lavinia redials, jumping up and down with impatience, anxiously breathing, almost in tears.)

LAVINIA: Shit! Ommm, ommm. Pink light! Pink light!

(Phone rings three times, answering machine clicks.)

GABRIELA'S VOICE: Hello, you've reached the Hauptman-Vasquez residence Please leave a message and we will call you back. Go ahead, Didi!

HESITANT CHILD VOICE: *Deje un mensaje por fa-vor.*

(Family laughter is cut off by long beep.)

LAVINIA: Manny, the Salvador Boys over there in Angeleno, they are NOT WATCHING YOUR BACK 'cos they said you don't run with them no more. They said ever since you became a slick

Hollywood deejay all you care about is getting high from them. I'm sorry you have to hear this, Gabriela—Mrs. Hauptman—but it's the truth.

I don't know why neither of you ever pick up the phone! And I'm gonna call the police. I know you both hate the police but I'm gonna go and call the police because you're both a crazy sick family and I'm sick of you! No, I don't mean that. I'm praying for you. I'm visualizing that you're okay, I'm sending you pink light. Oohmmm-mmm. Oh, fuck it! Fuck the pink light! I love you! Manny I love you. *Dios te salve, María, llena eres de gracia,* blessed art thou among women and blessed is the fruit of thy womb Jesus, Holy Mary, mother of God pray for us sinners now and at the hour of our—
SOUND: Beeeeeeeeeep.

The Rabbi's Cab Ride

Brooklyn, 2001

The Rabbi has a verbal tic of humming, sort of mumbling to himself, a sort of subliminal humming. He also draws out "yesss" and mumbles "very good" to himself often.

MIKE: Heya.

RABBI DAVE: Hmmm…

MIKE: Heya. Where to?

RABBI DAVE: Uh, umm Starbucks.

MIKE: Which one?

RABBI DAVE: Ahmm, the one with the, near the hospital with the Barnes and Noble bookstore attached.

MIKE: Oh, yeah, ok, you mean uh Park Slope, near the Park Slope uh Methodist Hospital? Brooklyn Methodist Hospital?

RABBI DAVE: Yes, yes yes exactly, thank you very good, very good, thank you, very much, yess. Yess.

MIKE: Okay, Rabbi, you got it. Stahbucks, huh, alright.

RABBI DAVE: Yess, good, good, it's uh, hmm. Hmm. I like eh the decoration. Very very very very decorated the cab, it's, the taxi, it's very decorated. Yes, you've got, uh, all the players.

MIKE: Oh. Got a problem with baseball, or?

RABBI DAVE: No, no, no love, like very much like baseball, very much love, love baseball very much.

MIKE: Ok, not a problem.

RABBI DAVE: No, not a, not a sort of problem whatsoever.

MIKE: Not a problem.

RABBI DAVE: But um. You got all the Dodgers, the players, the frames, yess. But, eh, is this, eh, satin or silk?

MIKE: Uh, actually, it's synthetic. But I, I bought it 'cause it's got, uh, the perfect blue. You know? It's that deep blue color?

RABBI DAVE: Oh yes, it's very, very accurate, very good, yes, it's very good, very good hmmm.

MIKE: So, you like it?

RABBI DAVE: Eh. Hmm. I'm a Yankees fan.

MIKE: Oh, yeah, how about that, Yankees fan? Alright, well. Not a problem. Religious guy, religious guys follow sports. I'm surprised, all right.

RABBI DAVE: And the catcher's mitt? The catcher's mitt right there?

MIKE: Oh. I rigged that up instead of the money tray, you know? You put yuhr money in there and you wheel it through on those little wheels that I got rigged up there.

RABBI DAVE: Yes, it's very good, it's very clever. You have your own museum.

MIKE: Yeah, yeah, you could call it dat—a museum. It's a—a guy the other night called it a mausoleum. I dunno. I just like to decorate, you know, I, I got this uh book you know about uh feng, feng chewy, it's this Chinese system of, of decorating whereby you pick things that signify—

RABBI DAVE: Oh yes, yes feng choy, I'm most familiar with it.

MIKE: Oh. You are? how about that? How'd you learn about that? How'd you learn about feng, a Rabbi, how'd you learn about feng chewey?

RABBI DAVE: Well, I was bwowsing with my Starbuck's in the bookstore and that's where I saw it, you know.

MIKE: Oh, yeah, how about dat? They got a very good self-help book selection dere. I like that Barnes and Noble, they got a good one right dere. I got a book there I like very much called uh *Heart Glue: Seven Sacred Steps to Mending Your Broken Heart.* You know that book?

RABBI DAVE: Is that by um Deepak?

MIKE: No, no, hey you know Deepak Chopra, that's pretty good. No, this one isn't, it's by Dr. Jeanette, Dr. Jeannette Gladjnois but uh you know a lot, you seem like, for a Rabbi, you know a lot about a lot of things, you know, from…you know, things. No offense but, uh, 'cause I thought you were Hassidim, you look like you're Hassidic.

RABBI DAVE: Yes. I am Chasid.

MIKE: Oh, no offense. Not a problem, not a problem.

RABBI DAVE: Uhmm, uhem, what may I inquire is the significance of the Jackie Robinson figure with the Chock Full O'Nuts cup glued in his hand?

MIKE: Uh, yeah. That's my Jackie-doll, yeah I made it myself, you like it?

RABBI DAVE: Ah, eh, and?

MIKE: Well, you know, Jackie was a great player, you know, he was one of the all-time greats, you know. I mean, even as a Yankees fan, Rabbi, you have to admit Jackie, Jackie was one of the greatest players that ever was, right?

RABBI DAVE: Uhmm. Nobody could steal bases better than Jackie.

MIKE: That's right! That's right! He was a great base-stealer, you're right on that, Rabbi. That was one of Jackie's many contributions to the game. And he was a great hitter also, I mean, he just played every angle of the game, he never gave up.

RABBI DAVE: Yes? And?

MIKE: Well, you know, after they tried to trade him to the Giants it broke his heart, you know? He retired early, he took that job working for Chock Full o' Nuts, you know? That's what happened.

RABBI DAVE: Yes, but why is Jackie Robinson in the relationship area of your feng choy bagua?

MIKE: Oh, wow! Holy shit! Pardon my French, pardon my French, Rabbi but, uh, you know a lot, you know a lot, you're a very knowledgeable Rabbi.

RABBI DAVE: Euhh, maybe eh Jackie would have liked San Francisco.

MIKE: What?

RABBI DAVE: No, the Giants, they went to San Francisco. I hear that they have very good café lattes there.

MIKE: Yeah?

RABBI DAVE: Yes. Maybe. Good muffins, too, at Starbucks, maybe good muffins.

MIKE: Yeah, see I, I didn't figure out the bagua map part of the Feng chewey there, 'cos it kinda confused me, 'cos you know, first of all, how do you find the front entrance to a cab? It's not like an apartment.

RABBI DAVE: It is simple. You start in the center.

MIKE: Oh yeah?

RABBI DAVE: Yes, always. Always in the center. It's the same in the Kabbalah and the Tree of Life. You start in the center, the Kabbalistic way, it's always like that.

MIKE: Yeah, well I had a hard time wrapping my brains around that bagua. It was a little complicated for me.

RABBI DAVE: Well, no it's exactly like a baseball diamond.

MIKE: Yeah?

RABBI DAVE: Yes, it's exactly like a baseball field. I worked it out, yes, on a coaster, on a beer coaster the other day when I was at the Yankees game, at Yankee stadium.

MIKE: You were at Yankee Stadium?

RABBI DAVE: Oh yes, Soriano won at the bottom of the ninth it was beautiful. It was a beautiful home run. It was a classic moment. Fifty thousand people were ecstatic, that's very important right now. Very imporant to be ecstatic. We took the train home together, the number four train, we were ecstatic! High fives everywhere! So, but I worked it out in the seventh inning before Sorriano's home run, I worked it out on my beer coaster.

MIKE: So you had a beer?

RABBI DAVE: Yes, And I worked it all out here: the Kabbalah, the Tree of Life, and a baseball field, they're exactly the same. OK, now, the Kabbalah it works uh in a snaking pattern, like a serpent's path, all right? And you're always in life moving from one place to the other, from—there are two pillars on either side. I will call them, to simplify it, the restrictive pillar and the expansive pillar, yeah? And you're always moving between them. In the middle is the median pillar.

MIKE: That I can understand. Middle, median, I understand that. Middle, median, yeah.

RABBI DAVE: And so it goes, I go from the back, up from the bottom. From the tenth place on the Tree of Life is *Malchut*, this is the back of home plate, that's Kingdom, yeah? And then directly in front of that, directly—these are both on the median pillar— you have, *Yesod*, ok, and that is Foundation, that's the front of home plate.

And then, moving, curving in the serpent's path going back- wards you come to *Netzach* and *Hod*, all right? That is Victory and Splendor, those are all the values of home plate. The Kingdom, Foundation, Victory, Splendor. All the values of home plate. And directly opposite that on the median pillar you have *Tiferet*! Beauty! The pitchers mound!

MIKE: Yeah, ok, I can sorta understand that.

RABBI DAVE: Yes! It's the center, it is the center, is beautiful. And above that, still moving in the serpent's path, we have *Chesed* and *Gevereh*, ok, this is Strength and Mercy, the two things you must balance for perfect pitch, perfect game, yes?

MIKE: Uh-huh.

RABBI DAVE: And then moving last you have the bases, first, second, third: *Hochmah*, at the top, *Kater* the Crown, and *Binah* okay? And this is not perfect, because really you're supposed to move in the other direction but those two are Wisdom and Understanding, and you see, Wisdom and Understanding are very often reversed and so this imperfection in my analogy is what really gives the analogy truth, do you understand?

MIKE: I, I dunno. I think I'm over my head here, Rabbi.

RABBI DAVE: You're over your head, that is good. That's *Kater*, that's the Crown of your head. At least you're on second base.

MIKE: So you think I should take the Jackie out of my relation- ship area of my cab bagua?

RABBI DAVE: I don't know, it depends uh what you are seeing in your relationships.

(pause) This is it.

MIKE: Yeah, this is it.

RABBI DAVE: Yes, well, let me find my money, and I will leave the cab. Yes, put it in the, the catcher's mitt.

MIKE: Ah. No offense, Rabbi, but uh, you know, you're going to Starbuck's at two o'clock in the morning, uh, you know, you had a beer at Yankee Stadium, uh, you know just out of curiosity, I mean, it's doesn't make any, it's all the same to me, you know, I, I'm not Jewish, I'm Catholic, well I'm divorced now, but I used to be Catholic, but uh just out of curiosity—is this all kosher?

RABBI DAVE: Yes, all, this is all kosher. It's all kosher. Very kosher. It's all very kosher. So I leave you my money and I leave you my card, it's got my website. Rabbi Dave Dovkind at L'hem dot org, means bread in Hebrew. Ok, you keep it—you need to call me, anything. Your name? (He reads the hack license.) Michael, Michael Rafferty. Be well, Mike.

MIKE: Be well, Rabbi.

RABBI DAVE: Maybe I'll see you next season at the Cyclones game, huh?

MIKE: (drives away, uncertain) Yeah. Maybe so. Unh-huh.

Manny Goes To Dodgers Stadium

Los Angeles, 2001

Two policemen wait in a squad car, outside Manny's apartment house. A young man emerges, carrying a huge plastic bundle on his back.

COP1: Here we go, this is the gang-banger the little *chola* called in about. Oh Lord, what's this little prick trying to put in 'is car?

COP2: Fuck if I know. Hate these gang-bang tips. Little fuckin' cholo terrorists—they hate America. Far as I'm concerned, they do us a favor killing each other. (He speaks into the police receiver) Hey I'm callin' in a Buick Riviera, plates read (squinting) H-4— 7?—2?—Can't read his damn plates.

COP1: Those hard contacts suck dude, I keep tellin' you. Get the soft contacts.

COP2: Whatever. Let's tail him, see what the hell he's up to. Maybe we'll get two for the price of one. (speaks into receiver) In pursuit. Request back-up.

(Cop1 nods and shifts gears. They pull off.)

MANNY: (He slides behind the low-slung Buick steering wheel. He pulls out.) It's going to be easy *Abuela,* Listen! Listen to that mix. Put in some fat jungle, yeah, now now rave it, rave it, carry it on over to the salsa side. Pa-Pow-oo. Awww…mmmm ye-ah! *Abuela,* you didn't realize, but your grandson is a genius. A mix-master beyond the mix, a mixhoudini, a mix whodono, a mix motherfucker. Sorry. I know you don't like it when I curse. *Abuela, lo siento.* I mixed you a funeral mix that will last you for-ever. Heh heh I'm going to bury it with you at the stadium. At Dodgers stadium. I figure between home plate and pitchers mound is good. So you can hear the sound the sound of the feet, the crowd screaming, the ball throwing, the hits. Right there with a view of where your house used to be on Calle Azulejo.

GHOST GABRI: (to Manny) You don't need to bury me there. I was buried there my whole life.

MANNY: I'm going to bury you and bury you and bury you, so you can suffocate them with your presence.

GABRI: Our family broke up into pieces.

MANNY: So our beat will go on and on inside them—

GABRI: The pieces are blown apart.

MANNY: —thumping in them saying Boom boom! Boom! *Abuela* Gabriela Is here—boom boom—in the *house*—

GABRI: —and if they weren't, there'd be nothing for you to mix.

MANNY: —in the *house*, in the *house*, behind home plate. Boom boom! In the *house!*

GABRIELA: Manny, I have to go now.

(She leaves him.)

MANNY: (He pulls up and parks.) *Abuela*, we're here. All that ugly-ass Dodger blue. There it is. Shovel. Ah shit! I don't got a shovel. Aw. See you always told me that *Abuela*—Manny you don't think ahead. You got to plan things better.—Hmm. Aw, well I use my hands. Come on, I gotta get you out the back seat. This is the one thing in my life I'm going to finish.

(He gets out of the car and stands up.)

COP2: FREEZE!

MANNY: (not hearing) Oh! I forgot your mix!

(He leans back in the driver's window to get the tape from the car.)

COP1: (Almost simultaneous; shouting louder.) Raise—your—arms—up—in—the—air—now!

(Manny turns in instant response, tape in hand, and is shot twice.)

Sacred Step Number One

Brooklyn, 2001/1961

ANGELA: Hey, Mrs. M. Hey, it's me, Angela. I came back to visit you again. I brought you a book, I brought you a book I'm gon' read you from a book I brought. Yeah, this, this white son gave it to me, yeah, this cab-driver son gave it to me? It's called *Heart Glue: Seven Sacred Steps to Mending a Broken Heart* and there's this one step, Step One, sacred step one, it made me think of you. It said: when your heart breaks it falls and shatters into many different pieces and to mend it first you must find the pieces. You must pick them up one by one and identify them. Mrs. M, that time that I saw you lying there in that blood in the courtyard at Ebbets Projects, that was like a piece of a broken heart. And that, that's why I keep coming back here 'cos I'm want to know where the— where the other pieces, where the other pieces of your broken heart, where the other pieces of the broken heart, where are they? Are they—are they around here? Are they in the room? I'mna look for you, I'mna look for you, I'mna look for you 'cos you can't tell right now so I'mna look *for* you. Oh yeah! Look at this old school, old school newspaper, back in the day newspaper. Look at that, it says—I could read good, yeah, I could write poetry too, yeah I'm smart.—It's a Brownsville Gazette, 1961—

MIRIAM: *Brownsville Gazette*, June 24th, 1961. Ode to a Brooklyn Stoop Sale By Miriam K.T. Flieschmann. When I first moved into my husband's Hy's bachelor digs, we agreed that I could redecorate. I decided to re-do the living room first and opted for the modern eclectic look. This, according to current interior decorator jargon, means a mixture of modern and older furnishings and accessories all arranged without strict regard to period. In other words mis-matchish and unstuffy is good. Hy and I prefer to call our version the Brooklyn Stoop sale look. First we had our own stoop sale and sold off the sofa and arm chairs his mother and

sisters had bequeathed on him. We also sold the department store coffee table. We got rid of the brown rug he had in the living room. A new family of West Indian immigrants down the block bought most of what we had and were very pleased with its Victorian intimations. Mrs. Kelly downstairs bought everything else. She collects stoop sales for her junk shop on Atlantic Avenue. I'm sorry, Mrs Kelly if you are reading this, it's called a curio shop and it's on Atlantic Avenue. Speaking of Atlantic Avenue, that is where a Moroccan gentleman sold me the pièce-de-résistance of my living room: an abstract mosaic tile table that reiterates all of the blues and the lavenders in the room including those of a marvelous rya rya rug that I have hung like a painting on the wall. Because of it's abstract design, it doesn't interfere at all with the purple leaf design of the new sofa (courtesy of the Catelano family moving to Conneticut) or the modern shag rug which is a bright red with blue striping (the Kaufmanns moving to Queens). To top it off we added modern built-in shelving for our books (this sold to us by a young couple off to Colorado) and arranged knickknacks—a mix of Hy's hallowed baseball autographs and my simple Mexican ceramics. *Et voilà*! A new living room.

As more people move to the suburbs, leaving all behind, the stoop sale opportunities grow. Alas, if our Parks Commissioner, Robert Moses, has his way there will be no stoops left by the end of the next decade. His zeal for tearing down the low rise apartment buildings and unique row houses of our Outer Borough neighborhoods in order to make way for his horrendous, large-scale projects must be checked. My motto is: Decorate while you can! Protest while you can!

M.K.T.—

ANGELA: —Flieschmann—

(Stops reading)

Mrs. M, tell me, tell me what happen on Easter?

MIRIAM: (in quavering voice) Go down Robert Moses, you old Pha-aroh and let my people go. I said go down, Robert Mooo-ses, you old Pha-roh and let my people go.

(Miriam's eyes open.)

HANNAH: (walks in) AUNT...MIRIAM?

ANGELA– Shh SHH. She's getting ready to sing—

MIRIAM: Hannah.

HANNAH: She's awake!

ANGELA: She's awake?

HANNAH: (friendly at first) Who are you? Wait, you're the one who attacked her! Nurse Doctor! Help!

ANGELA: Who beat you, Mrs. M, Who beat you at Ebbets?

MIRIAM: It was...the Yankees?

ANGELA: Huh?

MIRIAM: —or the Giants? Didn't they always beat us?

ANGELA: I'm fixin' to run. Y'all have fun.

(Angela runs away.)

HANNAH: Aunt Miriam!

MIRIAM: Hello, Hannah. I *never* liked hats. I never wore them.

Playback: Prayerscape

Echo Park Lotus Festival

Los Angeles, 2001

A Cambodian immigrant reads for her ESL class.

MAE PHO: 'The Echo Park Lotush Festival' by Mae Pho for Advanced ESL.

I go to the Echo Park Lotush Feshtival becaushe I love the lotush fla'ar. They blosshom up from Echo Park Lake every June and rise above big leaf that are like plattersh. I love to buy a plate of food from Cam*bo*dya where my parent were from and sit and eat and watch the lotush standing there. Over a thousand. There are many more lotus in lake in Cam*bo*dya and Thailan' and V*iet*nam. But dees are the most lotus they have in a lake in America. That is why we come to the Echo Park Lake and celebrate together ev'ry year. This is where we can see each other and remember. The La*ti*no people come too because they live here and they make the rides, the games and they make food too and sell t-shirts and jewelry for being Chi-ca-no. They have been here a long time. Longer than we have.

I watched the Thailand grandma dance the lotus dance. They move slow but silky, like ripples under the flat lotus pad leaf. They

never jerk, or sink, they float perfectly. I watched these 80-year-old grandmother and I cried about me and my daughter, that we have no family exchept each other. And I am so lucky but I don't understand why I have no older relative at all.

I went to sit by the lake and cry. An old Metchican lady ask me why: I telled her all my village die in Cam*bo*dya. I am afraid I forget my mem'ry to them. She tell me the Metchican have answer for mem'ry to the dead they call Day of Dead. It is also festival day of fla'ar.

Interrogation
Brooklyn, 2001

CHUCK: Come on De Mayo, come on baby pie. We got evidence on yuh now. We got your victim's hat with her hair and her blood, and we found it at your mama's apartment in Ebbets. How you gonna alibi that huh?

ANGELA: I told you I was at Coney. I had a Coney Island Easter. Coney Island. An' quit callin' me Baby Pie.

RICHARD: Leave her alone, Chuckie, she's cryin

CHUCK: Dat's what da *Post* says. She's called Baby Pie cuz she's born in a pizza parlor. Huhr dumb teen mama didn't know she was knocked up til she got delivered!

ANGELA: No, that ain't true. My mama was twenty-five and she knew she was pregnant with me but she went to Nino's to order herself a Baby Pie Pizza to go and an huh water came out at at that time and then Angelo called the ambulance for me and I was born in the hospital like everybody else. An Angelo he give me free pizza, he likes me. When he sees me call me Baby. You're

my Baby Pie. And everybody in the neighborhood call me BABY PIE And the the *Post* got that all messed up. The *Post* got that all screwed up. The *Post* get everthing screwed up.

RICHARD: Wait? Nino's Pizza? You go to Nino's oveh theh?

ANGELA: Yeah, I go to Nin's Pizza, yeah.

RICHARD: The one that's got an old framed photo of Ebbets Field and the other picture of old-time Coney Island, 1915, something like, Dreamland Amusement or—what is it? It may be Luna Park.

ANGELA: Yeah, it's Steeplechase!

RICHARD: Right!

ANGELA: Ye-ah. An' it got a old school clock. Italian coffee can clock

RICHARD: Oh yeah, I remember: dat *Moka d'oro* clock. Can't believe dat place. It's still there. I ain't been there for years. Pizza still good?

CHUCK: Okay, okay, could you step out of here fur a minute Richid? Make dat call?

RICHARD: Sure. Sure. You want anyting, Angela, a soda?

ANGELA: (instantly sharp and sullen) No.

(Richard leaves.)

CHUCK: (taking on the role of good cop) Maybe my partner's right. I'm bein' too rough with yuh, Angie. You're a person with a heart. Why you cryin?

ANGELA: Cause the old lady is dead.

CHUCK: Yuh victim? No, she's not, she's in a coma. My partner's callin' ta check on her right now. See? You still got time to do the right thing.

Cyclone

Brooklyn, 2001

An Indian man sits at the entrance to the roller coaster, alongside a huge lever.

COASTER OPERATOR: I watch the roller coaster. We run it now. It used to be the old Irish man had it before us for forty years. Now we are the operators. We sell the people the tickets and then they come through the red turnstile. They sit down in this roller coaster. Where I come from—New Dehli?—we don't have this rol-ler coaster. We don't queue up for these kind of entertainments. Yes, we love entertainments, we love a carnival or a circus as much as any people, but wee don't have these roller-coaster. Cyclone rol-ler coaster. Cyclone baseball team.

I asked an American man what does this word mean cy-clone. Has it to do with cloning? No, he told me, i'tis a storm, a wind, a great wind that goes counter clockwise in the Northern Hemisphere and clockwise in the Southern Hemisphere and wherever it goes it sucks eveything away and takes it to no place. I'tis a bad thing such as a typhoon, monsoon, or a hurricane, and here they name their entertainments after these disasters! That is not done in my country. But I like the rollercoaster. I like to watch.

Settin' Shiva

Brooklyn, 2001

Two old women knock at the door in a "South Slope"—or Gowanus—Brooklyn apartment building. The more portly of the two is breathing heavily.

LOUISE: My *gad*, no *won*der Miriam is dead, getting up those flights of stairs would kill anyone!

ALICE: That's not how she died, Louise. (The door opens. It is Hannah.) Oh! He-hello.

HANNAH: Hi!

LOUISE: *You're* the niece?

ALICE: Ha-Hannah, right?

HANNAH: Yes I'm Hannah Klug.

LOUISE: You should have told people about the stairs! That climb was horrible.

ALICE: Ha!—I'm Alice Morris, this is Louise Shiffman.

HANNAH: Hi.

LOUISE: Aren't you going to invite us in?

ALICE: Louise she's had a loss, don't be so—

LOUISE: So WHAT?! Miriam was older than I am and *I* should've been dead five years ago. I olmost died carrying this potato casserole up those stairs—I lost my balance on the fourth flight, the carpet is loose down there. It's hazardous: I almost went down and broke my neck.

HANNAH: Come on in, um...

(She lets them in.)

ALICE: We're sorry for your loss, dear. Miriam was a very good friend for many years.

LOUISE: We hardly ever sawr her. She stopped going to the War Resisters League years ago. We only sawr her at the Ethical Cultural Society when some writer would read.

ALICE: I—I brought you cookies. I was going to bake them from the ready-made stuff. I'm too tired to do my own these days, especially since September, the floors are sort of wobbly for me, but then I was worried about being uh, right so I got those Jewish cookies in the can? Coconut macaroons.

LOUISE: What? The cookies practice a monotheistic, uh, patri-archal religion?

ALICE: Of course not, Louise.

LOUISE: Then stop calling them Jewish, call them kosher.

ALICE: Well, this is my first sitting shivya, so I wanted to do it right, I'm not Jewish.

LOUISE: Neither am I! It's a religion not an ethnicity. Here's the casserole, Hannah, potatoes with cheese and hamburger. It's not kosher.

ALICE: See! You know these things.

LOUISE: Alice! I'm a socialist atheist. So was Miriam. Why are they doing this anyway? Miriam wouldn't have approved. (She sees Rabbi Dave.) Achh. Where'd you get the Hassidic Rabbi?

Lavinia's Prayer

Los Angeles, 2001

Lavinia prays for Manny, who is unconscious and lying in a hospital bed. She starts off in lotus, palms upturned in yoga mutra, meditating. Suddenly, she gets impatient, crosses herself, gets on her knees, and presses her palms together.

LAVINIA: Please *Guadelupe*, please help me forgive myself for calling those police. But first please, please help Manny come out of critical condition. Huh! He's been in critical his whole entire life! At the party in tenth grade, he was the sick super fly deejay, spinning all the monster mixes. Everybody had to be wit him and and then I went with him and he's all:—I'm not alive, Lavinia. I can't get up! I'm not alive.—Manny, maybe now since you had one

of those cop's bullets go through your collar bone and out between your shoulder blades, missing your heart by a beat. Now maybe you're almost dead, you can wake up and BE ALIVE for real. I'm alive *Guadelupe*, and I been praying for him for a long time.

(She hums, *ohm*—ing almost as if she were saying the rosary.)

Okay, let me visualize. Let me connect with him. Pink light. No, he's in gray light, standing on a corner. Loitering there on a corner. Everything is gray. No colors. Oh, but there are colors. Bright green, ruby red, yellow and surrounded in bright, bright pink. *Guadelupe?* I see you! Oh yes! I see you, you are in all the colors there. Painted so beautiful. I can see your merciful face, *Guadelupe*—on the hood of that car? Diamonds, your robes are studded in diamonds, the whole car is covered in your white roses. It's so beautiful. What is that car, Guadelupe? It's the low-rider, it's the *low*est rider I ever saw. It's so *low* it goes be*low* the ground. It slows down. The rose-tinted windows are unrolling. Who's in that car?

Josh's Cab Ride
New York City, 2001

JOSH: Hi.

MIKE: Heya.

JOSH: Uh, Brownsville, Brooklyn. Union and Blake. You know where that is?

MIKE: Not a problem.

JOSH: (Josh looks around the cab, says nothing. Cell phone goes off.) Josh Klug, talk to me. Yo, Kim bro', what up? Yeah I'm

back. I'm in the cab. Well it was a bit disconcerting flying in, yeah bro', the skyline is absolutely fucked. My eyes started to water. I'm telling you, it just didn't look right. It got to me. Crazy-mad. Crazy-mad, I'm tellin you. So how'd the meeting go with the Bank of Korea dudes? Alright. Yeah. They gave you the dot com crash shit. Yeah, yeah, but you turned 'em around. Dope. Okay. Not dope, but doable. That's doable. That's in effect. Shit, I wish I was there. This is not a good time to leave. Right, I've got those. As soon as I can bust out the laptop, bro. This funeral thing with my sister is going to take the rest of the afternoon over here. Okay. Later, bro'. Thanks for covering. Later. Thanks. Bye…La Guardia's not too crowded huh?

MIKE: Well, it's betta den last month. It was empty. Nary a soul.

JOSH: Is that right?

MIKE: At's right.

JOSH: It's my first time back since—

MIKE: Oh yeh?

JOSH: Yeah.

MIKE: You from here?

JOSH: Well, I'm from the Island.

MIKE: Not a problem.

JOSH: Yeah, but my mother had a sister here. My aunt. She stayed in the 'hood, you know, a die-hard Brooklynite.

MIKE: Uh-huh.

JOSH: Which I suppose you know it turned out to be right; the real estate prices are awesome now—

MIKE: Uh-huh. Lotta traffic on the BQE, they're doin' construction dey never finish. Seems like twenty years from now dey'll still be doin' dis.

JOSH: Yeah. Well that's okay. I got time. My aunt is dead.

MIKE: Okay.

JOSH: My sister pretty much forced me to come. (Cell phone rings.) Josh Klug, talk to me. Yeah. What? You're cutting out, you're cut—call me back.

Interrogation

Brooklyn, 2001

Richard cracks open the door and motions with his head for Chuck to come over. He speaks quietly.

RICHARD: Chuck. Bad news. The victim expired yestiday. But we got a problem.

CHUCK: What?

RICHARD: (whispers) The niece insists huhr aunt never wore hats.

CHUCK: What the fuck? How's she know?

RICHARD: Dat's what she says.

CHUCK: She does not.

RICHARD: She does. She insists. The victim's dying words were against hats. I told you a hat was a stupid ting tuh plant. Why'd I listen to a young punk like you? We gotta drop the case. De Mayo? You're free tuh go.

ANGELA: Mrs. M is dead? Mrs. M is dead?

CHUCK: Yeah, now get outta here.

RICHARD: Here's a kleenex, Angie. And, uh pick up your doll at the front desk.

CHUCK: What are you talkin' about?

RICHARD: She checked in a doll. She checked in a doll with Officer Boyle. I dunno she had a big doll.

CHUCK: Get out of here! (Angela rushes out, still sobbing.)

What are YOU crying for? Yuhr retirement? Dey ain't gonna find out we planted it. We'll bury it.

RICHARD: I'm not. I got congestion. Maybe I got anthrax and I'm gonna sneeze on ya!! Go get out of here! Get rid of the evidence!

CHUCK: Aright! (slams out)

Richard sits.

Josh's Cab Ride

New York City, 2001

MIKE: So you goin' to a funeral?

JOSH: Ummm. Not precisely we're sitting Shiva. It's a Jewish thing.

MIKE: Right I heard of it. Sitting Chivas. Everyone brings food. You sit with the body. You pray. I always wondered is there Scotch involved wit dat, or...

JOSH: No, it's called *shi*va. I'm not really into it. I'm not Jewish. My sister is but I'm not. She didn't used to be she got into it again recently...

MIKE: Yeah, alot of people are going back to their religion lately. You need someting, you know, to get yuh through a time like dis.

JOSH: Yeah, yeah, my sister's been sending me e-mails about it. I've been watching CNN, but uh, I've been in Korea the whole time.

MIKE: Korea? I had a cousin in Korea.

JOSH: Yeah, I run a hi-tech company there. My partner is a Korean-American, so...

MIKE: Dese Koreans are incredible. They're branchin' out inta everything. Even baseball. They got dat pitcha, Kim.

JOSH: Yeah. The Diamond Backs.

MIKE: Kid's a pretty good pitcher. ow! Did I feel sorry fuh him. Dat fifth game. Soriano scoring that home run off him in da ninth. Oo, I felt sooo sorry fuhr dat guy.

JOSH: Not me. Those guys won the World Series. Fuck 'em.

MIKE: Oh, I take it yur a Yankees fan.

JOSH: Yeh, my whole life.

MIKE: Not a problem.

JOSH: I guess you're Dodgers fan.

MIKE: Brooklyn. The Brooklyn Dodgiz.

JOSH: Yeah I can see you got this cab pretty tricked out. The blue ceiling,

MIKE: Yep.

JOSH: Pretty good, yeah. What's this ball and bat with faces painted on them?

MIKE: Aw, dat's my singin' ball and bat. They sing. I wrote da song myself. Pull on 'em and deysing a little song. G'ahead.

JOSH: Uh, no. That's alright. You know, this is sort of an outsider art piece.

MIKE: Outside who? Outside the plate?

JOSH: No, no, it's a genre of art that's very popular in Japan and, it's catching on in Korea. American outsider art. It's like art by people who aren't artists.

MIKE: Yeh, naw, I ain't an artist, I'm just doin dis for the love of it, you know. Love of the Dodgers.

JOSH: Yeah, I could see that. You got all the players. Shuba. George Shuba, that's an obscure one. He was a good batter, right?

MIKE: You got that right.

JOSH: I don't see Jackie Robinson though.

MIKE: Oh yeh. He's my favorite. I made a doll. A Jackie-doll.

JOSH: Awesome. You made it yourself?

MIKE: Yeh. I—took it down cuz, uh, someone told me it was bad feng chewy. So I—

JOSH: You sell it?

MIKE: No.

JOSH: You could sell this. All the players in blue velvet frames: Furillo, Campy, Erskine. All the fifty-five champions, right?

MIKE: Hey, you know alot fur a Yankees fan.

JOSH: Oh yeah, my Uncle Hy was a Dodgers fanatic. He was my Aunt Miriam's husband. He wouldn't even watch baseball after they moved. He blamed radio and TV for killing the Dodgers. That's wrong, though, because the fans fill the stadium out in California. But he was a stubborn guy. He stopped completely. Secretly, you know, I think he still followed it because he liked to ask me how the Yankees were doing. Only to insult them of course.

MIKE: Of course. Dat's how I was. Up until last week. But I dunno, I had ta go back y'know, wit evertin dat was goin on and the series. What an incredible series!

JOSH: I know! Two consecutive games with that bottom of the ninth turnaround. I mean that's baseball history right there!

MIKE: Absolutely! In-fuckin-credible. And it just seemed like they were meant to win for New York, for everybody. You know Guiliani goin' to Arizona to see the last two games.

JOSH: Right and then this expansion team from *Phoenix* wins the World Championship!

The Candy Dish
New York City, 2001

GHOST MIRIAM: Oh! I had things I wanted to tell Hannah. Poor Hannah. I wanted to say so much more to her. I had a whole list of items but they went right out of my head when that man in the long coat stood in the doorway. Scared me, I thought it was death. And it was.

I wanted to apologize for leaving the apartment such a mess. So cluttered. All the closets filled to the brim. I meant to clean them out, but I never got around to it. Same as Hy. I did manage to throw away some of Hy's things after he died. But I never threw away Hy. I put his ashes in that covered brass dish. Opened the plastic pouch from the crematorium and poured them in there. We were atheists I didn't know what to do with them. I figured I might as well keep them close to me. I kept them on the dresser. In the Springtime I'd get very sexually aroused by those ashes. More sexually aroused than I ever was all my years with my first husband Lonnie, with Hy, or anyone. There I was in my mid-eighties, deeply sexually excited by a candy dish full of ashes. That's why I had to go for a walk that Easter day. It started sunny but it got cold and dark in the afternoon. I walked and walked and walked all the way to Flatbush.

Settin' Shiva

Brooklyn, 2001

RABBI DAVE: Hello. Welcome. Rabbi Dave Dovkind. Take off your coats your hats, grab a plate. Sit down. Relax.

LOUISE: See? Already he has to control everything. Typical patriarchy. Since when were you so orthodox? I mean, I knew your mother, Ester.

ALICE: Miriam's sister?

LOUISE: Yes, Ester still practiced, but I assumed reform. Now not only do we have to come sit shiva, but you've got a fully out-fitted Rabbi here. What's the—

HANNAH: I met him at Starbucks.

LOUISE: You whaat?

HANNAH: In April, the day after Aunt Miriam got attacked. I was all alone. I went for coffee at Starbucks and there was Rabbi Dave and we had a long conversation.

ALICE: I was very sorry she was attacked that was so terrible. In the papers on the radio. We went to visit her in the hospital but um but um—

LOUISE: But she was in a coma. So we went to the cafeteria.

ALICE: Louise don't say that.

LOUISE: Why not? It's the truth.

RABBI DAVE: There's a Starbucks in that hospital. Near there in the adjoining building, on Seventh Ave.

LOUISE: Oh yeah that's what I mean. We didn't like the cafeteria. We went to that Starbucks

RABBI DAVE: Mmmhmm did you try the muffins? They're unusually good I think.

LOUISE: Are you kidding me? They cost about four dollars and seventy-five cents, I'd never buy a muffin from them. I had a two-and-a-half dollar cup of tea.

RABBI DAVE: This is where I was going the night that Hannah's aunt passed away. I'm so absent-minded I arrived there at two a.m. wanting a café latte and a muffin. Of course, it was closed.

ALICE: Are we talking the Starbucks on Seventh Avenue? Oh yes that closes at ten, I believe.

RABBI DAVE: Yes, I learned this. It was two a.m. I was four

hours too late. So I thought, maybe there is another reason I'm here. So I went into the hospital, I walked and walked up four flights. Four hours late, four flights up. Down three hallways—

LOUISE: Is this numerology or Judaism?

RABBI DAVE: —and I walk into the seventh room and there was my dear friend Hannah with whom I had such a wonderful conversation at Passover.

HANNAH: What happened was Aunt Miriam had come out of her coma. She talked to me for just a little while. Then she died just as the rabbi walked in.

ALICE: Amazing.

HANNAH: It was awesome.

ALICE: Really, almost makes me want to become Jewish.

LOUISE: Alice, you're a socialist.

ALICE: It's not an ideology, Louise. It's a religion.

(The door bell rings.)

HANNAH: Oh. (she goes to the door) Hi, I'm Hannah, Miriam's niece.

MARIE MARGARET: How're you doing, Hannah? Marie Margaret. I'm so glad you invited me. I baked a little macaroni and cheese casserole I hope that's all right.

HANNAH: That's great. Marie Margaret. She knew Miriam from—

MARIE MARGARET: From church.

LOUISE: What? Now we find out Miriam got religion too? Was she a Baptist? This is too much!

MARIE MARGARET: No, I'm Episcopalian actually but she wasn't part of our congregation. Miriam participated in our program for endangered youth.

HANNAH: This is Louise and Alice they knew her from—

LOUISE: From leftist politics.

MARIE MARGARET: Oh, okay that's nice. Very good. Mmm hmm.

HANNAH: And I this is my Rabbi friend, Dave Dovkind.

RABBI DAVE: Sit down, relax. Grab a plate.

MARIE MARGARET: So nice to be invited. Miriam was a wonderful lady. She was always talking so fondly about her niece and nephew.

LOUISE: Oh, where is the nephew? Isn't he the only other living relative besides Hannah here?

RABBI: Yoshua.

HANNAH: Yeah, uh. He just flew in on a, he's coming, he just got off a plane from Korea.

LOUISE: Korea, what? Are they cluster-bombing there, too?

HANNAH: No, no he owns a high-tech company.

LOUISE: Oh! Same thing. Late-stage capitalist globalization, same thing.

MARIE MARGARET: Mm. This is delicious.

LOUISE: Oh, you like it? You like the potato-meat casserole? I'm glad you, gee thanks, I didn't think anyone would like it. (Louise is suddenly shy, almost sheepish.)

MARIE MARGARET: Oh no, I like it very much. Mm. You're gon' have to give me your recipe.

LOUISE: Ah, I didn't think anybody would like it. Gee thanks.

(Louise is touched.)

HANNAH: I loved my Aunt Miriam so much.

(Hannah chokes up.)

RABBI DAVE: Just relax.

ALICE: Um. I've never sat sh, sh, shiva before so, uh, I don't speak Hebrew but if we're supposed to pray then I could do the, the words along with the uh, with the rabbi, and...

RABBI DAVE: No, we're just going to sit for now. We're going to sit. It's a form of prayer, let's just sit for awhile, sit.

ALICE: Because I've, I've never done it before.

MARIE MARGARET: I've never done it either, but it doesn't seem too hard. Mm. Mm. We're just simply sittin'.

ALICE: Just—just sitting.

MARIE MARGARET: Just sittin' sheeva.

ALICE: Shiva, shiva.

MARIE MARGARET: Sittin' shiva.

Lavinia's Low Rider Vision

Los Angeles, 2001

LAVINIA: Who is in that car? Who's driving? A *vato* with big arms covered all over in tattoos, weareen a big hat. Why won't he show his face? Ah, it's a yellow skull. Mmmhmm. And now the back window unrolls. There's a whole crew of people b-but I see someone... It's Gabriela, Manny's *abuela*, she's putting something on her head. Oooo beautiful lace, the color of yellow rice that saffron color and yellow flowers woven in it. She's pointing. *Si*, she's getting married, married to that *vato*. They're going to a big party and the driver wants Manny to come spin. Don't go, Manny don't go. Manny, stop walking around the car. Stop and look at the Guadelupe on the hood. She's telling you to go back, come back to your Lavinia, come back and be alive. Don't go in that wedding car with your *abuela* and her skeleton groom, come back to the living. We need you for the dancing. We need you to come out of critical. I need you for my own wedding. I need you to live with me. In Echo Park or in Angeleno Heights. I don't care. We can rent an apartment in the valley and have a pool. Heaven is not paradise.

The Guadelupe is telling you—Don't go toward that open door—step back, out of the pink light, out of the gray light, into *this* light.

(Lavinia opens her eyes and surveys the room.)

It's another smoggy day, and I don't think the City of Angels Hospital has ever washed these venetian blinds, but there's light coming through so open your eyes because paradise is here. I'm sure of that. Paradise is here.

Josh's Cab Ride

New York City, 2001

JOSH: Ever *been* to Phoenix?

MIKE: No, no I never have.

JOSH: Oh, well, I have. It's, there's just one big strip-mall and housing development for as far as the eye can see. It's hell, essentially. It's hell with air conditioning.

MIKE: How about that? And they go and win the World Series. I thought it was destiny, you know. I thought this one time it's, it's destiny that, that this is the worst time in all time for New York, it was destiny for them to win it for everybody

JOSH: Yeah, I know. I wept.

MIKE: Me too. There were tears coming down my cheeks. I dunno, it just seemed they were about to win, they were sooooo close.

JOSH: I know and then they turned it around like that in the bottom of the ninth. That was, Womack, fucking Womack you know, it sucked.

MIKE: I'll tell you something though. Last couple of days since then I felt happy.

JOSH: Oh, yeah, 'cos you're a Dodgers fan at heart, you hate the Yankees.

MIKE: No, it was the opposite, it was, uh, for once the, the Yankees weren't floatin' above everyone else, you know, lordin' it over the rest of us. For once, they lost, they suffered a loss, like the rest of New York, you know. And it, it came to me that it was destiny, but it was destiny for them to lose, it was destiny for them to lose so that they could give us hope. So that we could have something to live for. So that we could pray for next year.

JOSH: Spoken like a true Dodgers fan. Let me off here, keep the change. Uh, listen, I'm gonna, gonna give you my card. If you ever want to sell that Jackie-doll I think I could take it to Korea with me and sell it in a gallery you know or, I was thinking you might even want to do a website of all this. See you later.

MIKE: Yeah, no, I, I gave the Jackie-doll away actually, I gave it to a little kid.

JOSH: You gave away a hand-crafted, outsider-artist Jackie-doll?

MIKE: Yeah, yeah, little black kid I know, she was upset, she wouldn't tell me why, so I gave her the Jackie-doll.

JOSH: You're a good man. You're a better man than I. See you later. Catch you next time.

MIKE: Yeah, next season.

Brooklyn, 2001
Angela
Angela lies in bed with the Jackie Robinson figure.

ANGELA: I can't remember, Mr. Robinson. I can't. (doing a Jackie voice) Don't give me that mess, Angela. You know!

No, I hum. She sing the words. I can't remember.

(in a Jackie voice) Bull! YOU STEP UP TO THE DARN PLATE NOW. YOU SING!

(Angela tries and fails to sing, so "Jackie" starts. She joins in on the second line.)

Gggggggggggo, down Robert Moses you old Phaaroh, and let my people go, I say go down y' ole Moses, tell old pharaoh to let my people gooooo.

(Sings real lyrics, fully, Jackie joining in.)

Go down Moses, way down to Egypt la-and, tell old Pha-aroh to let my people go,

Let my people go.

The Party

Astral Sidewalk, All Times

Skullvato pulls up in his low-rider, music thumping. Gabriela is in the back seat and waves to Miriam who stands on the curb.

MIRIAM: Gabriela! What are you doing? What's wrong with this car? It's so low.

GABRI: It's a low-rider. Come on, Mrs. Miriam, climb in the backseat with me. I'm getting married. We're all getting married. I'm going with this man.

SKULLVATO: Yes *chicas*, there's a bride and a groom for everyone. We're going to the mondo stadium mariachi free jazz rocknroll house jungle rave. We're going to dance and dance. Twenty-four hours into eternity.

MIRIAM: Every one getting married? Sounds like Moonies to me.

GABRI: Come on. Mrs. Miriam, get in. Let go of the loose ends! Let's party.

MIRIAM: (A little scared) Well, eh, Gabriela I don't think I can go. I've never believed in all this.

GABRI: Come on! Just get in! Get into the car! (Leans forward to Skullvato) It doesn't matter if she doesn't believe, right?

SKULLVATO: No this is for everybody, man, everybody. *Todo el mundo.* Come on, *tranquiliza-te, chica.* Get in!

MIRIAM: Oh, alright. (climbs in back)

SKULLVATO: Put on a bridal veil. Excellent! Okay—*Vamanos*!!

He peels off, bass thumping.

Cyclone
Brooklyn, 2001

CYCLONE OPERATOR: I like the rollercoaster. I like to vwatch these people. It used to be only black people and brown ones. Not brown people like us. Brown people from south of United States border. It used to be these children are the only ones on the roller coaster. But recently more white American people have been on the queue. The baseball team Cyclones has brought them. They walk around and they say, Vow, they are re-witalising it! It is not so BAD anymore. They see that there are some other white Americans here to make it safe for more white Americans. And there are many many police officers there to protect them from black people committing their crimes against them. I like to watch them, risking their lives, now they are safe, to ride up and down and around and safe to come near death on my roller coaster. I call it mine, although I do not own it. I like to watch.

Lotus Festival
Los Angeles, 2001

MAE PHO: Metchican lady tell me when she was little girl on Day of Dead Festival children carry altar for dead with skeleton who sing and dance and play guitar. An old lady with no teeth bake yellow sugar skull for the chiwdren to eat. She throw fresh yellow mar'gold fla'ar under their feet and the petal crush between their toe. She telled me now no more festival like this. Her village is awso gone. Her grandchildren celebrate American Halloween. She give me napkin to rub my tears and mango on a toothpick wit hot chili pepper and lime. It was spicy! We sat together and look at the lotus fla'ar. The large green leaf cur' up at the edge in breeze and pink and white petals open to heaven. Inside is center like flat yellow moon with bumps. In September, they will fall down, lay flat, then sink under the mud. But this day they standed tall, like a crowd of people waving. There were many many in blossom. Over thousand.

Cyclone
Brooklyn, 2001

OPERATOR: At night in the summer I see the pink and blue and yellow halos by the Cyclone baseball stadium. We turn on our sign and we are all like decorations in a grand festival. Large, beautiful, pink letters spell Cyclone. (In sing-song voice):—*C-Y-C-L-O-N-E*, *see-why-see-el-oh-en-ee*, *I-like-it-here-by-the-sea.*— When people come out off the Rol-ler coast-er, I look at them. For a moment, there are changes. They resemble gods. The ride

is so fast, it has momentarily shaken their lives from their shoulders. They are detached. Their eyes are shining like gods' eyes. They walk down the ramp, but by the time they reach that stand that sells the corndogs and pistachio ice cream and cotton candy, their lives have run after and climbed back in them. They are normal Americans again.

ABOUT THE AUTHOR

Heather Woodbury is a native of northern California. In her late teens, she moved to NYC's East Village, and became involved in the early 80s performance art scene where she developed her method of generating material via improvisational writing and performance. Her first "living novel," *What Ever* (FSG, 2003) was a ten-hour solo theater piece, directed by Dudley Saunders, which toured the U.S. and Europe, and was adapted as a radio play hosted by Ira Glass. Woodbury has received numerous awards as a performer and playwright. She is the recipient of the inaugural Spalding Gray Award and was recently awarded an artist's fellowship from the City of Los Angeles to commission new work in 2007. She currently resides in Echo Park, Los Angeles with her husband.